DIGITAL

photo processing

A step-by-step guide to creating perfect photos

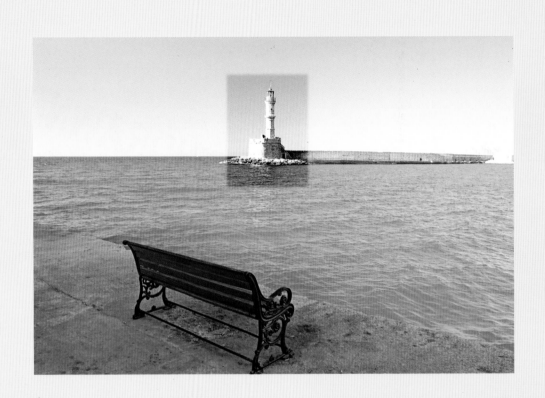

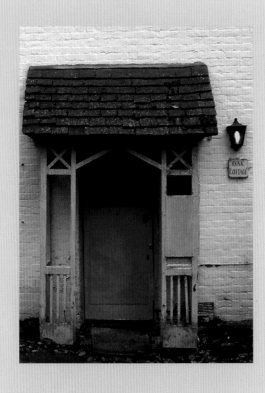

DIGITAL

 photo processing

A step-by-step guide to creating perfect photos

CHRIS TARANTINO

MUSKA&LIPMAN
Publishing

First published in the United States by Muska & Lipman Publishing, a division of Course Technology, in 2003.

For Muska & Lipman Publishing:
Publisher: Stacy L. Hiquet
Senior Marketing Manager: Sarah O'Donnell
Marketing Manager: Heather Hurley
Associate Marketing Manager: Kristin Eisenzopf
Senior Aquisitions Editor: Kevin Harreld
Manager of Editorial Services: Heather Talbot
Senior Editor: Mark Garvey
Retail Market Coordinator: Sarah Dubois

ISBN 1-59200-106-8

5 4 3 2 1

Library of Congress Catalog Card Number: 2003108392

Educational facilities, companies, and organizations interested in multiple copies or licensing of this book should contact the publisher for quantity discount information. Training manuals, CD-ROMs, and portions of this book are also available individually or can be tailored for specific needs.

MUSKA & LIPMAN PUBLISHING,
a Division of Course Technology
(www.course.com)
25 Thomson Place
Boston, MA 02210

www.muskalipman.com
publisher@muskalipman.com

This book was conceived, designed, and produced by
I L E X
The Barn, College Farm
1 West End, Whittlesford
Cambridge CB2 4LX
England

Sales Office:
The Old Candlemakers
West Street
Lewes
East Sussex BN7 2NZ
England

Publisher: Alastair Campbell
Executive Publisher: Sophie Collins
Creative Director: Peter Bridgewater
Editorial Director: Steve Luck
Series Editor: Stuart Andrews
Editor: Adam Juniper
Design Manager: Tony Seddon
Designer: Kevin Knight
Development Art Director: Graham Davis
Technical Art Editor: Nicholas Rowland

Printed in China

For more information on this title please visit:
www.ssreus.web-linked.com

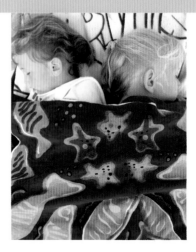

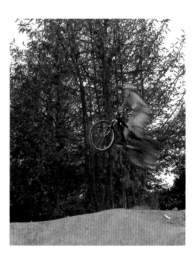

Contents

Introduction

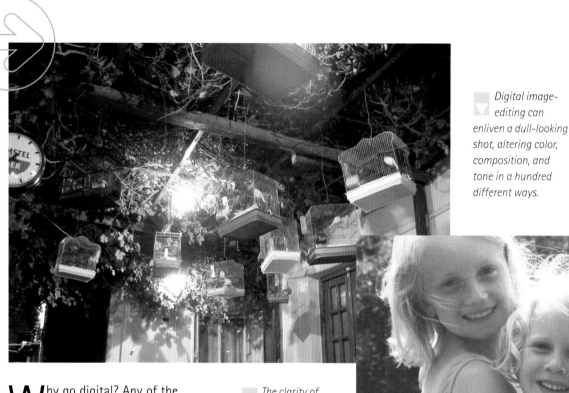

Digital image-editing can enliven a dull-looking shot, altering color, composition, and tone in a hundred different ways.

Your computer will allow you to recreate styles, like this sepia tone, without damaging the original image.

The clarity of this image owes as much to digital trickery as it does to photographic skill.

Why go digital? Any of the thousands of photographers who have made the move would be able to answer that question, but maybe you're one of the few who are sticking with film until the bitter end. Maybe you've been taking analog pictures for years, you might have taken a few courses, or earned a degree in photography. You may have set up your own darkroom, with all the equipment and knowledge that that entails. Maybe you just liked taking rolls of film to the developers, and the thrill of looking through the prints to discover that fantastic shot has come out exactly as you hoped.

On occasion, you may have taken things one stage further. Some of your best shots could look even better, so you have a studio scan in the print or the negative and adjust the resulting file to suit what you are looking for. Then, you get back a new negative or print. This new print might look exactly as you envisioned, but it might just look more like what the developer thinks it should look like, and even the best developers can't always guess your intentions. So much for sitting down and telling them what you wanted.

There is one message at the center of this book: with digital technology, you can take control of your own shots. There is now a huge window of opportunity open to anyone who wants to decide exactly how their final photo looks. All you need to do is educate yourself in the new, digital world.

GOING DIGITAL

Doing so won't force you to spend vast amounts of money on equipment, or become some sort of computer whiz-kid. You don't need a supercomputer—a basic Macintosh or Windows PC will do fine. Digital cameras, meanwhile, are not in short supply. You can find one to fit any budget, and their capabilities improve on an almost daily basis. If you just want a simple camera to shoot pictures of your family on vacation, then there are models that take care of everything for you. If you're a professional photographer who demands complete control, then there are plenty of options for you, too.

Either way, you won't look back. The beauty of taking a slew of shots, pausing to check them out on the camera's LCD screen, then choosing to keep some, delete others, and

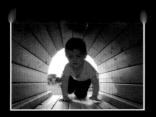

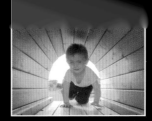

Going digital is sometimes a difficult decision for experienced photographers, but few look back. Your original images can be preserved or even restored, while a variety of adjustments and effects can be applied with ease.

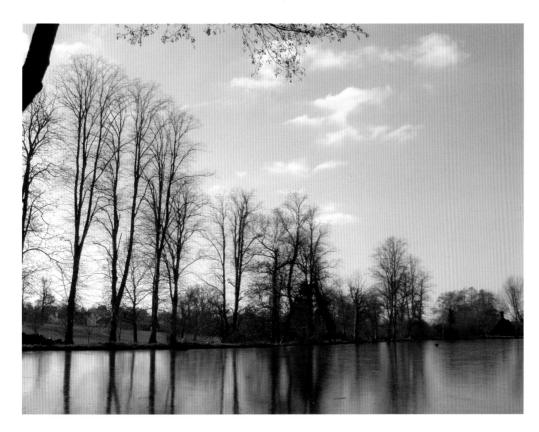

Before a little help from the computer, a whole section of this image had been torn away.

reshoot a few can't be overstated. And the argument that digital is just too noisy is not a good one any longer. I followed that argument for a while until I started retouching at a shop that caters to the boutique crowd of photographers. These people are insanely critical of their work, and, yes, many of them still use film cameras. But some of the biggest names in photography are discovering digital and some are never going back. That's a good enough endorsement for me.

Not convinced? This does not mean that you are left out in the cold. The quality of digital scanners has come so far that you can get absolutely amazing results. Scan in your slides or negatives, and the quality rivals what you might get from a really good digital camera. I should clarify that, by scanner, I don't mean the hundred thousand dollar kind.

Today's average desktop scanner has very high optical resolutions, and while this doesn't always mean extreme amounts of detail, it does mean a better capture. Even basic scanners are getting better at capturing shadow detail, and many scanners now capture images at a bit-depth of16-bit per channel. This is a huge amount of color information, which means that you can use software to tweak your colors by an enormous degree, without experiencing any deterioration. Any film negatives or prints that you have can be scanned in and manipulated easily, without losing anything in quality.

What good is being able to capture photographs in such rich color if you can't print them? With older inkjets, you rarely matched the quality of the demo prints. Now printers are appearing which deserve

to be called "photo-quality." Some even reach archival status. You can get smudge-proof, waterproof, and quick-dry all in one, with the printed dots so small that gradients appear smooth. That makes for nice flesh tones, and with the addition of a good color management program you can almost guarantee consistent output.

Introduction

Before digital correction, this model had facial blemishes, freckles, and even a slightly different jawline.

This snap was taken with the whole scene in focus. A digital blur on the background makes the boy stand out.

This motion blur effect, added afterward in software, really brings the action to life.

IMAGE PROCESSING

So you know that you can capture and output high-quality prints. That's great if that's all you want to do, but if it is, then you're still missing out. The real joy of digital imaging—and the focus of this book—is the way that it enables you to squeeze every bit of potential from your photos. You might be someone who likes to tweak photos to get what poor exposure might have missed, or an artist who does artwork based on photographs, or you might like to play with color or focus to create something amazing from a simple photo. Whatever you do best, it is all made easier with digital image processing.

There are so many capable programs out there that it might be hard to choose. Most scanners, and some cameras, come with some form of Adobe Photoshop. Whether it's Photoshop Elements 2 or Photoshop itself, you can do quite a bit with your photos. You can adjust color the way we used to in the darkroom, rescue shots from the horrors of poor exposure, or composite multiple shots together. You can change backgrounds easily, and even add text if you wish. For most of this book, we'll be using Photoshop Elements: a reworked version of Photoshop designed to offer consumers an entry-level program that they could use easily and effectively.

Photoshop proper is the industry standard for image correction and manipulation. With this program there is almost nothing that you can't do to an image. The masking is more capable than Elements. There are more color correction tools, like *Curves* and *Color Balance*, and the compositing features are exceptional. Elements is hardly limited, however, and both programs offer plug-in compatibility. This means that there are untold numbers of filters out there that can make your ideas even easier to achieve. Some mimic camera lenses and color filters, others add texture or distortion, sharpen, blur, or alter colors. The list goes on.

This book will show you how to recreate the effects shown here, and many more, using Photoshop Elements. This popular program is widely available, easy to use, and lends itself well to both simple corrections and more complex projects.

Before color was added in Photoshop, this shot was black and white.

When this woman posed for the camera, she was sitting by a swimming pool.

USING THIS BOOK

The book begins with a listing of the applications used, and all the basic information that you need. We then look at simple corrections, before going in-depth on more advanced manipulation. Simple-to-follow projects will take you through the methods and build up your knowledge and skills. We then move on to portrait retouching, before finishing with detailed coloring work. By the time you've finished, you'll know everything you need to make perfect pictures. With each image that you work on it will get easier and you will find yourself trying more and more things. Welcome to the digital world.

1 Digital imaging

What do you need to know about digital imaging? First of all, that what you need most, beside digital images, is imagination and patience. If you have ever worked in a darkroom then you probably have all the patience in the world, and if you are already taking pictures then there should be no lack of imagination. After that, it helps to know how digital images work. By understanding their capabilities and limitations, you can start to expand your own.

Photoshop and Photoshop Elements

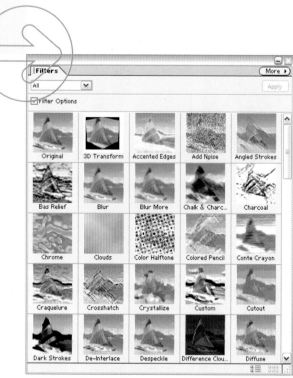

Filters, common in image-editing software, allow you to instantly change the feel of an image.

Using layers enables you to split images into discrete components that can be worked on independently .

If there's one company that's almost synonymous with digital-imaging software, it's Adobe. Of the company's products, two have become standards for manipulating photographic images. One is Photoshop—the leading application for professional art editors and designers. The other is Photoshop Elements, a consumer-level application geared to the home enthusiast. While it doesn't have all of Photoshop's features, Elements still has most things a digital photographer could wish for, and at a fraction of the price of Photoshop proper. It also has a lot of useful quick fixes to help you make the most of your digital shots.

Elements comes chock full of hints and recipes for getting things done. These are based on commonly made corrections or effects in the professional imaging industry, including a number of Web imaging features, text, and painting effects. These recipes are updated or added to by Adobe periodically, and can be accessed by going to the *Palette Well* at the top right of the screen and clicking on the *How To* tab, or by selecting *How To* from the *Window* menu.

Both programs offer layers. These act like sheets of transparent plastic, overlaid on your photo, which can be worked on, adjusted, blended, added, and removed at will. Using layers, you can make an endless number of color corrections and effects without ever damaging the image. You can also duplicate the original image layer, enabling you to

change the image's pixel makeup without losing the original data. Elements and Photoshop both offer adjustment layers, allowing you to make drastic changes to color and tone without changing a pixel underneath. Photoshop has the added ability to mask (protect) areas of the regular pixel-based layers and make isolated corrections. While masking in Elements is limited to adjustment layers, this is still very powerful.

Both programs offer the ability to composite multiple images together very quickly and accurately. Each image can still be color corrected and manipulated separately, and any adjustments made can be undone.

Elements has all of the filters that were available before Photoshop 7. The filter interface makes it easy to decide which to use by providing large thumbnails in the *Filter*

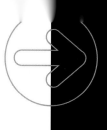

Adobe Photoshop is the leading image-editing program and it, or its junior version Photoshop Elements, provide a huge range of flexible tools for editing pictures, from point-and-click effects to brushes and more.

The Photoshop *Liquify filter has more options than the Elements version, but the latter is still a powerful effect.*

Like many of *Photoshop's tools, the* Texturizer *filter allows you to apply a range of preset styles...*

palette. This can also be found docked in the *Palette Well*, or opened by going to *Window > Filters*. Filters can also be accessed under the *Filter* menu at the top of the screen.

Photoshop 7 offers additional filters, such as a *Texture Generator*, and an enhanced version of the Elements *Liquify* filter, which enables you to warp your image, interactively, using brushstrokes. It also supports some color modes and color controls that aren't on offer in Elements. Still, both programs can open each other's layered files, so you can always go between one and the other if necessary. While Elements is limited in its ability to do intricate masks or professional color output, it is a very capable program for getting your feet wet in the digital age. And, if you ever outgrow its features, it's the perfect introduction to Photoshop itself.

...as well as letting you load your own texture effects.

If the built-in *features don't give you the tools that you need, many programs (including Photoshop Elements) allow you to buy "plug-ins" to extend their capabilities.*

Image-editing applications

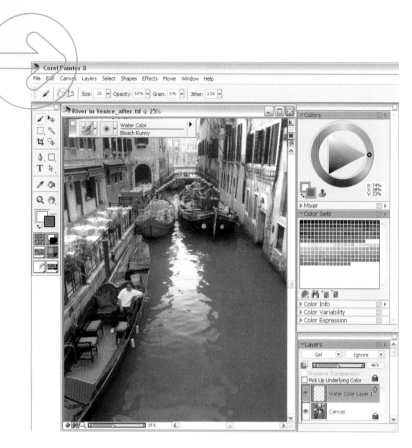

A dobe isn't the only developer in the graphics software field, and there are a lot of competent image-editing applications out there besides Photoshop and Photoshop Elements. While we use these two applications for the projects in this book, there's no reason why you can't get the same results from another company's package. Corel Photo-Paint and—for PC users—JASC Paint Shop Pro both have comparable features, while Deneba Canvas offers a fully integrated package, combining photo-editing features and sophisticated drawing tools in one program.

Corel Painter simulates much of the artist's toolkit.

The most direct rival on both the Mac and PC formats is Corel Photo-Paint. It offers excellent compatibility with layered Photoshop files, and has all of the tools of Elements plus more complex tools for layers, selections, and masking. In some respects, it actually outdoes Photoshop, and its layering, retouching, and blending capabilities are every bit as advanced. There are situations where one app is clearly better than the other, but Photo-Paint is a perfectly credible alternative.

JASC Paint Shop Pro has been on the scene for a long time, and has always been promoted as a cut-price rival to Photoshop. In the last few versions, Paint Shop Pro has almost lived up to that billing, and it's certainly a tough rival to Elements. A slightly clunky interface holds it back, but some effective tools and a bargain price help make up for that.

While not a direct competitor, Procreate Painter is still a key part of the digital artist's studio. Less daunting and more user-friendly than it used to be, Painter can't be beaten for the way it mimics nearly any kind of natural drawing or painting technique, and it gives you complete control over paper texture, paint types, and brush size, right down to individual bristles. All of this takes a hefty hit on your computer's processor but if you are looking to turn your photos into artwork, this is an awesome program, and Painter also has some powerful color correction tools and excellent color management.

PLUG-INS

Plug-ins are smaller programs that "plug-in" to an application to add extra features or effects. Both Photo-Paint and Paint Shop Pro accept

Though for many, Photoshop is king, there are plenty of other options in the world of digital imaging. Not only that, but a hardened user might find that they enjoy the additional functionality offered by plug-ins.

Plug-ins can help create special effects, like crumpled paper...

...or provide enhanced tools, in this case to cut objects from their backgrounds even more easily than Photoshop allows.

JASC Paint Shop Pro is a budget alternative to Photoshop, with great Web features.

Photoshop-compatible plug-ins. Many developers offer these, including Corel which offers some very effective tools that work in any Photoshop plug-in compatible programs. One, Corel Knockout, is a masking program that makes short work of complex cutout selections. It can cope with hair and transparency, for example, if you're pulling human subjects away from backgrounds.

Corel KPT Collection is the latest version of a classic set of effects plug-ins, and includes some impressive special effects, including realistic lightning and a filter to make your image look like ripples in water. It also offers excellent gradient capabilities.

Extensis Mask Pro is a masking program on par with Procreate Knockout. It has a great interface and also makes short work of any complex masking situations.

Plug-ins allow many effects that would otherwise take a good deal of time to be done in minutes. Of the many options, Alien Skin has a good reputation for easy interfaces and responsive filters. The Eye Candy series provides excellent special effects on the lines of KPT Collection, but includes some more that are also useful, including tools to add textures or photographic grain. Eye Candy also has a great Shadow Lab for building shadows. Image Doctor, another filter by Alien Skin, is the perfect plug-in for any Elements user who envies Photoshop's *Healing Brush* or *Patch* tool. If you spend a lot of time retouching portraits, it may be worth making this small investment.

ORGANIZATION

Keeping all of the digital or scanned in images organized can be a monumental task in itself. To accomplish this there are numerous products out there that offer renaming of images, rotation, keywording, etc. Mac users will find Apple's iPhoto with their machines, which even includes some correction tools. Windows users feeling left out might be interested in Adobe Photoshop Album, with a very similar feature set that includes the option to order hardcover books or calendars.

Pixels and resolution

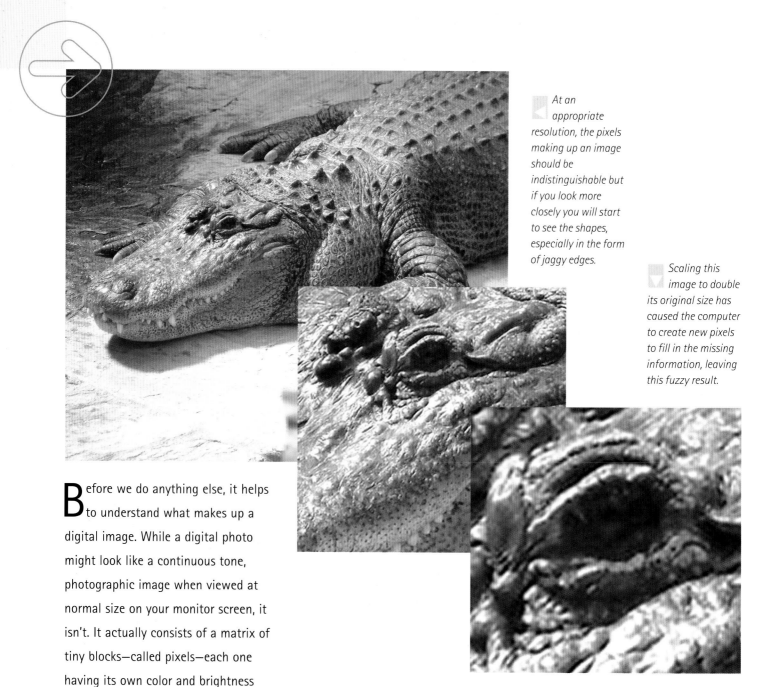

At an appropriate resolution, the pixels making up an image should be indistinguishable but if you look more closely you will start to see the shapes, especially in the form of jaggy edges.

Scaling this image to double its original size has caused the computer to create new pixels to fill in the missing information, leaving this fuzzy result.

Before we do anything else, it helps to understand what makes up a digital image. While a digital photo might look like a continuous tone, photographic image when viewed at normal size on your monitor screen, it isn't. It actually consists of a matrix of tiny blocks—called pixels—each one having its own color and brightness values. Normally these pixels are so small that you can't actually see them, but zoom in on an image using the magnify function in an image-editing or viewing package and eventually the blocky pixels will emerge.

You would never have to worry about any of this if it wasn't for one thing: resolution. Resolution is a way of defining the amount of visual detail in a digital image in terms of how many pixels fit into an inch of screen area or onto an inch of paper, expressed as pixels per inch (ppi).

For example, take a landscape image shot with a 2-megapixel digital camera. At the highest quality settings, the grid of pixels will be 1,600 pixels wide by 1,200 pixels tall. On an average 17-inch monitor this image will look fine even if it takes up the full screen. This is because the resolution of a monitor is usually taken as 72ppi. As long as there are 72 horizontal x 72 vertical pixels for every square inch of screen space, the image seems like a continuous tone photograph.

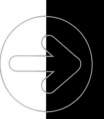

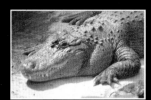

Resolution should always be a concern when editing digital images. The quality of your final output will be all the better if you remember that your images are composed entirely of little squares of color.

The image on the left here is 300ppi, whereas the one to the right is 72ppi. The difference is clear on the page, but would not be on the computer screen which has a much lower resolution (usually taken as 72dpi).

Print, however, is less forgiving. For true photo-quality, you need a resolution of 300ppi. If you take that 2 Megapixel shot and try to print it out at a size of 10 x 8 inches, you will notice that the result doesn't look so great. At worst, the pixels become visible, leaving the shot with an ugly, blocky appearance. At best, the image might lose some of its tonal density and detail. This is because, printed at this size, you only have 160 horizontal x 160 vertical pixels to fill each square inch of the paper: in other words the resolution drops to 160ppi. With some images, you may be able to get away with a resolution as low as 150ppi, but these may not stand up to close scrutiny.

The easiest way to check the size and resolution of an image is to load it into your image-editing package and check. If you're using Photoshop or Photoshop Elements, select *Image > Size* from the *Menu Bar* and look at the physical dimensions and the resolution.

RESOLUTION AND RETOUCHING

Resolution becomes even more of an issue once we start manipulating images. Certain alterations can have a negative effect on image quality, and the less resolution you have to work with in the first place, the more noticeable this degradation can be. While this goes across the board, resolution becomes particularly important for the following three types of operation:

• Cropping (see pages 36-37). Imagine taking a shot measuring 8 x 10 inches at a resolution of 300ppi. To improve the composition and remove some dead areas within the frame, you crop away an area that takes up approximately half of the shot. If you still try to print it at an 8 x 10 inch size, the resolution will drop to 150ppi, leading to a noticeable drop in quality.
• Montage (see pages 100-103). When creating composite images, you may want to use originals of different sizes and/or resolutions. If you want to take an element from one image and copy it into a larger image, then you will probably need to scale it up to fit. If the resolution is too low, then the transposed element will look blocky and out of place.
• Filters. Some filters and effects, particularly artistic brush filters and textures, need a certain amount of detail to work with if you want to get more than a coarse result.

If you need to, it is possible to rescale or resize an image beyond its physical resolution—in Photoshop or Elements, just make sure the *Resample* box is ticked when you resize. However, there are drawbacks. To fill in the missing pixel information, your software uses interpolation to "guess" what should be there from the information it does have. As this guesswork can't create detail that isn't there, interpolation often adds an unintentional blurring to the image.

FACT FILE

Digital camera file formats

By default, most digital cameras save images in a compressed JPEG format, with several quality settings. While using lower settings means that each shot takes up less space on your memory card, it's best to stick to the high-quality settings. JPEG compression is a "lossy" compression format, meaning that it loses data in order to keep file sizes small. This loss causes blocky artifacts to appear that spoil the image when viewed up close. To avoid artifacts completely, many cameras can save in a TIFF format, which retains all the information in an image, albeit with a larger file size. Mid-range and high-end cameras can also save in a RAW format, with additional color information. Unless you take or edit photos for professional publication there is no need to use it, and many image-editing packages don't even support it.

Digital color

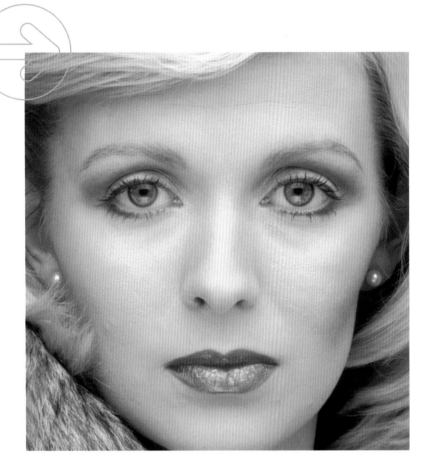

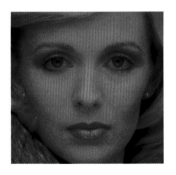

The original image is made up of pixels described in terms of the amount of red, green and blue that make up each pixel.

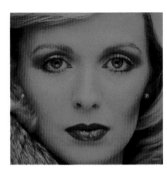

The channels show the areas of the image with the highest red, green or blue values. Note that dark areas in each channel correspond with the darker areas in the combined image.

When everyone used film and prints there was no need for most of us to worry about the science behind color. You either bought a color film or a black and white one, and—unless you did your own developing—the rest was up to the processor. You don't need to know much more in the digital world, but it's still helpful to understand how digital color works, especially if you want to get to grips with the more advanced color adjustment techniques.

Color theory is a vastly complicated subject, but only a little bit of it need concern us here. We need to understand how a computer and image-editing program understand color. For now, the best way to do so is to understand how a monitor, scanner, and digital camera see color—in terms of mixtures of red, green, and blue. These are not the same colors you may remember from mixing paints at school for one very good reason; all of these devices work with light.

Your monitor, for example, is black when you turn it off. White is the lightest color it can produce, and it can only create this by adding red, green, and blue (RGB) light together (we call this additive color). By varying the amount of each color in the mix, every other color can be represented. The same happens with each pixel in a digital image. Of course, computers being computers, they like

to think of this in terms of numbers, so we have red, green, and blue color channels, and each allows for a certain number of shades—in most digital images, 256. With three 256-color channels mixed, this means that each pixel can represent any one of a total of 16.8 million colors.

Cameras and scanners also measure light in terms of RGB values. The CCD sensor in a digital camera takes light coming through the lens and splits it into red, green, and blue values. When you are working on a digital image, the ultimate result as far as each individual pixel is concerned is a change in its color values.

Image editors need to think of color in many ways, from the RGB of the camera and the monitor to the CMKY of the printer, to the transition between the two. Luckily the computer can assist with this, but the theory helps nonetheless.

▼ Red, green, and blue mix to make white, with cyan, magenta, and yellow as secondary colors. This is how your monitor works.

▼ Cyan, magenta, and yellow mix (theoretically at least) to make black. This is how your printer mixes colors.

▼ Typing values into the R, G, and B boxes of the Color Picker allows you to define any one of 16.8 million colors exactly.

In most image-editing applications, you can select a color to work with by typing RGB values into a dialog called the *Color Picker*. To add further confusion, however, a lot of operations use a color system called Hue/Saturation/Lightness (the last is sometimes called Brightness). Using this system you choose the pure, basic color (the *Hue*), the level of *Saturation*, from white, through a light tint, to the deepest level, and the *Lightness* (from the dullest shade to the brightest color tone). The best way to get to grips with this is to open a *Color Picker* and play around with the sliders.

PRINTED COLOR

Your printer, however, works differently. It starts with a white surface and uses inks to move away from that color (we call this subtractive color). Typically these inks will be cyan, magenta, yellow, and black (key), or CMYK for short. Some more expensive "photo printers" also use additional shades to make it easier to mix colors. Cyan, magenta, and yellow are the primary colors from art class, and mix to create a full range of colors. Black is theoretically unnecessary, but is used to overcome the risk of muddy browns and bad alignment that mixing three colors brings up.

There is a slight catch, however. Even at a professional printers, CMYK cannot offer quite as complete a range, or gamut as it is sometimes called, of colors as RGB. This is something your image-editing program and printer software will try to compensate for using automatic color correction. Strong greens and blues, however, will always look a little better when seen on the screen than they will when printed out on the page.

If you use Photoshop 7 or Photoshop 8 to prepare images for publication, then you will need to understand more of the technical issues surrounding CMYK. Photoshop Elements, however, handles everything for you. As long as you understand RGB, you'll be fine.

Calibration

To keep your monitor and printer running in sync, and to avoid any unpleasant surprises at the printing stage, it is essential to set up your monitor so that it displays the most accurate colors possible. Windows and MacOS both have built-in monitor calibration utilities, and others are supplied with some graphics applications. In Windows XP, locate your *Control Panel* and you should find an icon for the Adobe Gamma utility. Double-click it to launch the utility, then follow the simple steps. If you are using MacOS X you will find a similar utility built into the operating system's *Control Panel*. On older MacOS 9 systems you should find a Macintosh version of the Adobe Gamma utility listed under the *Apple* menu.

Preparation

File compression reduces image size, but often at a cost to quality. This original is 5.49MB in size as a TIFF file of 1,600 x 1,200 pixels.

Saved as a JPEG, the file is much smaller. A high quality JPEG is 418Kb (top), medium quality is 200k (center), and low quality is 116Kb (bottom).

Retouching your images often involves working on small areas, and this work can be compromised by inappropriate quality settings. Even before you start taking pictures it pays to start thinking about the next steps. What are you going to do with your images? How many are you going to take? Both of these issues are affected by your camera settings before you even get to the computer. Once shots are transferred you still need to be careful about how you store and organize your images. It's all about preparation and good working practice—dull stuff, but dull stuff that can save you heartache later on.

The image taken with your digital camera is the highest quality version you will ever have, so think about your needs even before you press the shutter release. Most digital cameras offer a choice of file formats and quality options (see page 15), some of which reduce image quality to save on memory-card space. The choice is up to you, but when an image is compressed to a JPEG, there is nothing you can do later to get the missing detail back.

If you use Photoshop or another application that can cope with the extra color data, you can use the RAW format, but in many cases it's overkill. Use the TIFF format in situations where image-quality is the prime concern, and JPEG at a high-quality setting at all other times.

Similar advice applies if you use a scanner to digitize existing prints and negatives. Scan at a high resolution, and save your scan in a TIFF format, not as a JPEG.

ORGANIZATION

It's easy to transfer images from your digital camera to a computer, but if you don't want to lose images, then you need to be organized.

Most cameras come with proprietary software to help transfer files, and this will offer some organization options. As you will want to reuse the memory card on the camera, the images you move to your computer should be put somewhere safe. Use the folder your software chooses, or keep a folder on your computer called "My Photos." If you save your images to a new titled subfolder each time you transfer, you will find them much easier to find later on.

Alternatively you can get dedicated software to help you keep track of your snaps, such as the free iPhoto supplied with Apple Macs, or Adobe Photoshop Album for Windows. These programs take care of the downloading and storage of images in their own way, and offer easy options for printing and presenting images, and also for backing them up.

It's good working practice to keep your folder of original images backed up by copying it to CD or DVD on a regular basis. Computers are not indestructible, and it would be terrible to lose photos permanently if, for instance, the hard disk were to break down.

Making sure you follow some simple rules when taking, opening, editing, and saving your pictures can prevent the loss of vital detail or even the entire original shot.

A File Browser *is a handy way of looking at images and quickly picking the one to work on.*

The Save As *dialog allows you to save the current file under a new name and in a different format.*

Image-editing file formats

There are many ways of storing images in digital form, but these are the file formats you will use most often.

TIFF: The professional's choice. Nearly all applications can read it, it retains detail and color information on a pixel-by-pixel basis, and it can even be extended to store additional data (such as layers or color profiles). TIFFs can be compressed using the lossless LZW compression method, meaning no data is destroyed.

PSD: The native Photoshop format, and one that can be read by many other image-editing applications. PSD retains layers, channels, and color information, so if you save finished work to a different format, it's worth keeping the PSD.

JPEG: The JPEG format uses "lossy" compression, discarding information (so sacrificing image quality) to save file space. You can choose how much data (and detail) you lose when you save. JPEGs are useful when reducing files for e-mail or internet use.

RAW: Used by high-end digital cameras as a "digital negative," RAW stores all that the camera saw and the decisions made by any automatic settings. It is possible to get a Photoshop plug-in to read the RAW files produced by common cameras.

GETTING READY TO WORK

However you organize your images, you will always start your retouching by loading them into your image-editing application. In Photoshop Elements this will usually be through the *File Browser*. Select *Window > File Browser*, and a dialog will present you with a directory tree to the top left and a window full of thumbnails on the right. To get information on a picture without opening it, click on it once and the details will appear beneath the directory tree.

The golden rule for any image-editing is to always keep a safe copy of the original. The best way to do this is to select *File > Save As* as soon as you open the image, and save a working copy under a new name in a different folder. Use this file instead of the original while you work.

As far as the format is concerned, the native format of the application is best. In the case of Photoshop or Photoshop Elements, this will be PSD. Both applications can store images in other ways, but using a PSD is the only way to ensure all the necessary information is saved with your images. Also, a PSD can be read by both Photoshop and Photoshop Elements on either the Mac or PC. Never use a compressed file format, especially a JPEG, to save an image you are working on. The compression makes an image worse with each save, like a pirated video tape that's been copied too many times.

Workflow

There is nothing to stop you from loading an image into Photoshop Elements and making whatever corrections and manipulations you choose in whatever order you wish. All the same, the expert retoucher knows the value of a more systematic approach. Due to the way that Photoshop works and the way that certain operations affect a digital image, it pays to follow an effective workflow, even if this won't be the same in every case. There will always be situations in which you need to be more flexible.

HOW TO WORK WITH AN IMAGE

1 Import an image into Elements via a film or flatbed scanner, digital camera, or photo CD. This is generally done using *File > Open* or by *File > Browse*. This will take you to any files saved on your computer or archived to CD. If you want to scan an image, select *File > Import*. Most cameras come with special software to download the images onto your computer.

2 Now save the image in a more appropriate format. Go to *File > Save As,* create a more descriptive name for the file, and save it as a Photoshop (PSD) file.

3 Before you do anything else, create a new copy layer. Use *Layer > Duplicate Layer* or, in the *Layers* palette, drag the background layer over to the *New Layer* icon at the bottom (the curled page in the middle of the three icons). This allows you to keep the original background layer intact, so that if you have any catastrophes you still have the original layer to work on. Always create a duplicate layer before you start work on an image.

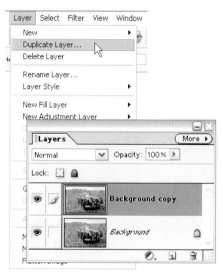

4 Crop, resize, and straighten the image (see pages 36-39). If you aren't sure of the image's final use, it might be best to crop later for the sake of flexibility.

DIGITAL IMAGING

Take time to assess your image before you start work. If a shot needs a lot of complex work, it helps to have a mental checklist of corrections to follow. You won't always end up following the plan, but it will help avoid missing out a step.

5 Make general tonal and color adjustments using the *Quick Fix* tools (see pages 28-29) or the *Levels* command (see pages 30-33). At this stage, if you are happy with the result you may duplicate this layer and throw away the original background layer.

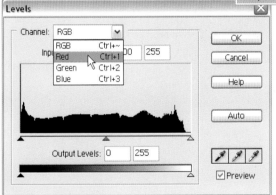

6 Make selective local adjustments to color and tone. For smaller areas, use the Dodge and Burn tools. For larger areas, use *Levels* and the *Hue/Saturation* controls in conjunction with the selection tools: the *Rectangular Marquee*, *Lasso*, *Magic Wand*, and others.

7 It's now time to do any serious retouching. Remove any unsightly blemishes from your shot by using the *Clone Stamp* tool (see pages 90-93), and apply other techniques to clean up the shot.

8 Create any special filter effects. Once again, use a duplicate layer for each one.

9 Sharpen the image (see pages 40-41). This can give an appearance of sharper focus, but don't overdo it or the results will look ugly.

10 Save the image. Use *File > Save* to keep the file name and format the same. Use *File > Save As* if you want to rename the file or change the file format from, say, a Photoshop PSD file to a Web-friendly JPEG format.

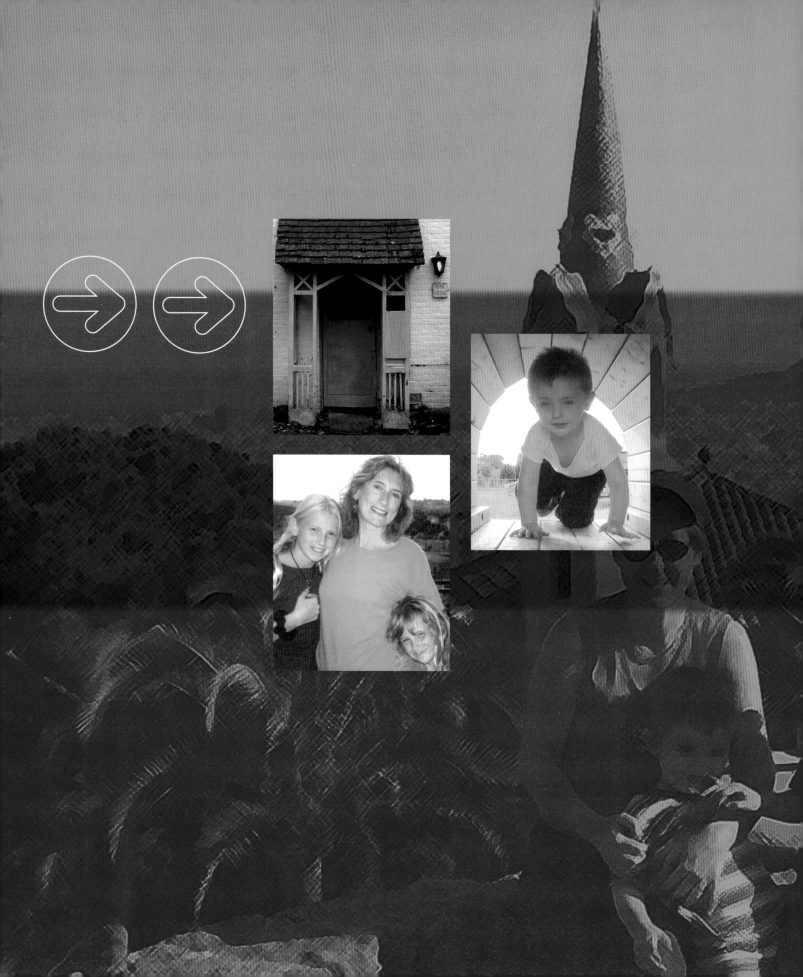

2 Quick fixes for better photos

We often think of retouching as a slow, painstaking
process, but some of the most profound changes we
can make to an image can be done in seconds.
Contrast, color, and exposure faults that used to
ruin shots can now be cured with a few clicks of the
mouse, while focus can be adjusted with a similar lack
of effort. This chapter takes you through these basic
corrections, and then introduces a few more complex
features that will change the way you retouch forever.

Auto corrections

Some images have a good feel to them: the depth is fine and the colors vibrant—and yet they still seem to be missing something. With other images, something has obviously gone wrong. The colors look out of balance, there's no tone to the image, and everything looks flat. Basic image-editing software can help in either case. Photoshop Elements has three great automatic correction tools, found under the *Enhance* menu.

Uncorrected picture

1 Sometimes it doesn't matter what auto correct tool we use. In this example *Auto Levels* and *Auto Color* produce results so similar that either would be considered a success.

2 If you tried doing the same thing on this vacation image you would be in for a surprise. Each *Auto Correct* option produces very different results.

Auto Levels *Auto Color*

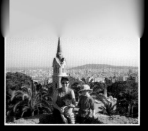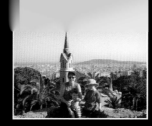

Auto Color, *Auto Contrast* and *Auto Levels* are easy ways of correcting imperfections in a digital image. Try out these easy-to-use functions before attempting to correct the flaws manually.

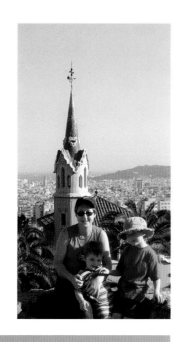

Auto Correct Features

The best of the auto correct features is *Auto Color* correction, found under the *Enhance* menu. This option combines the *Auto Levels* and *Auto Contrast* features. Usually it will offer you the best "instant" color correction.

Sometimes, the three functions will all give you very similar results. If there is only a contrast problem in the image, the obvious solution is to use *Auto Contrast*. If the image has a color cast problem you can use the *Auto Levels* option or the *Auto Color* correction. But what if the highlights are overexposed, but the color is okay? Similarly, what if the color is off and the contrast is poor? Think about the result you want before you start to make corrections to an image.

Don't expect the result of any of these quick fixes to be the final word, necessarily—sometimes your image will still need a little more tweaking. All the same, start with these options. You may find that you have finished correcting the image in double-quick time.

TIP If you find you don't like the result of a correction, you can always click Command -Z (Ctrl-Z on a PC) to undo your actions.

3 The *Auto Levels* introduces a yellowish/green cast to the image. Keeping this correction would result in additional color corrections, which is never desirable if there's an easy way to avoid it.

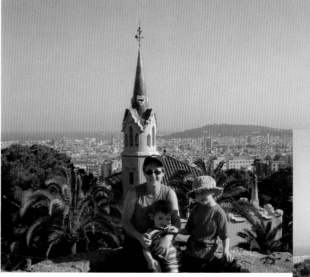

5 For this image, the miracle cure turns out to be *Auto Contrast*. It opens the picture up without changing the overall color balance. The result is more detail in the trees and a nice separation of the foreground from the background.

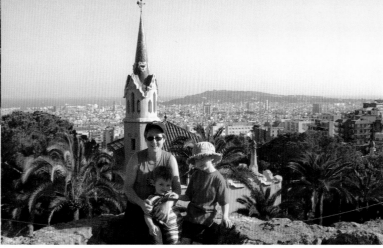

4 The *Auto Color* correction option will make almost no visible change. It makes the image a little darker, at the same time adding some red to the greens, correcting the color cast but at the price of some contrast. The image will need additional correction, although not as much as would be needed had *Auto Levels* been used.

Correcting exposure

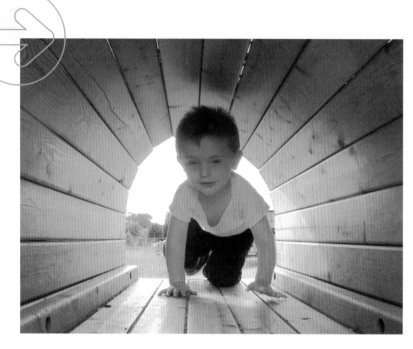

2 Under *Enhance* > *Adjust Lighting* there is an option entitled *Fill Flash*. As its name implies, this control mimics the effects of a flashbulb, filling in light from the side. However, our digital flashbulb has a big advantage over a real flash: it automatically protects the parts of the image that are already correctly exposed.

There are occasions when the exposure is wrong no matter what you did when you took the picture. The shot that looked great in the viewfinder of your camera looks too dark or too bright by the time it gets to your computer screen. And if it looks that bad on screen, it's not going to print out well either. Fortunately, there are plenty of options in image-manipulating programs that can tackle and solve these problems. Although some of these can be complex, for now we will look at the simple, semiautomated options that allow you a relatively minor degree of control over the desired correction.

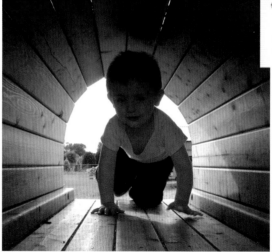

1 Look at this shot of the boy in the play tunnel and you can see that the facial features are there but barely recognizable, and the shadows of the tunnel are also very dark. These things could very easily have been avoided if a flash had been used. Highlighting a problem onscreen can sometimes make it easier to decide on which option to use when fixing it. This is one occasion when using a computer monitor to spot problems can pay dividends.

3 The *Adjust Fill Flash* dialog box is a simple one. There are two sliders. One controls the amount of light and the other the degree of saturation. The *Lighter* slider goes from 0 to 100 with the midpoint clearly marked. Adjust the *Lighter* slider until you're happy with the result. You can't overdo it because you'll start to see strange banding appearing when the shadows are opened too far. You will also start to lose detail in some of the lighter of the dark areas. A setting of around 35 works well in this example.

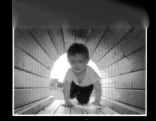
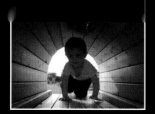

Although the corrections to these two images could be done manually, semi-automatic features in image-editing programs such as Adobe Photoshop and Photoshop Elements can save you a lot of time and trouble.

ADDING A BACKLIGHT

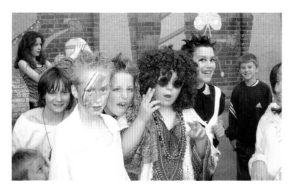

1 This image of children at a party is a very nice shot—sharp, bright, and colorful—that at first glance does not seem to need any adjustments. Look closer, however, and it appears a little flat. The white shirt on the girl in the foreground seems overexposed, the details in the hair are not as deep as they could be, and the children don't seem to pop off the background enough. The picture overall could be a bit darker, but not to the extent that the background becomes as dark as the people.

2 In Elements select *Adjust Backlighting* under *Enhance* > *Adjust Backlighting*. This feature is semi-

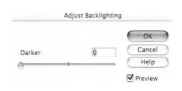

automatic, in that it protects an area. In this case it protects the darker areas of the image and allows you to add tone to the lighter areas. The dialog box that pops up is even simpler than the *Fill Flash* and contains only one slider.

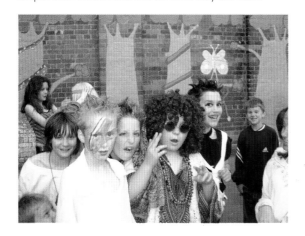

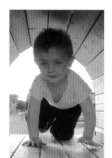

4 Adjusting the light can take out some strength and color from the affected parts of the image. This is where the *Saturation* control is useful. Sliding this to the right will bring back some of the punch to the color, while sliding it to the left will desaturate any bright color that might be uncovered during lightening. The image now shows some highly saturated reds. Move the *Saturation* slider to the left, to about 35—don't move it too far, or the skin tones will turn gray. One thing to note is that the saturation adjustment will only work when the light has been changed.

RECAP

Ⓐ Brighten
Use the *Fill Flash* enhancement to lighten up a dark image without blowing out the highlight areas. Adjust the light upward...

Ⓑ Saturate
...then boost the *Saturation* to bring some punch back into the color.

Ⓒ Backlight
Use the *Adjust Backlighting* enhancement to add tone to lighter areas without muddying shadow detail in the image.

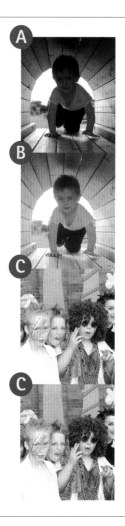

3 This image does not need a big adjustment, so moving the slider to the right to about a 5 or 6 should do the trick. By this point we have a lot of detail starting to pop in that gives the image some depth. Shadows in the cheeks start to fill out and the background turns a little darker, making the children stand out more. Anything larger than this move will start to gray out the image and make it flatter. With this option there is no way to bring out more detail or tone in the white shirt. The collar is completely blown out, and there is not really much that can be done. The shirt could be masked and have density added to it using *Levels*, but this will only add to the existing pixels and leave it paper white.

Adjusting the tonal range

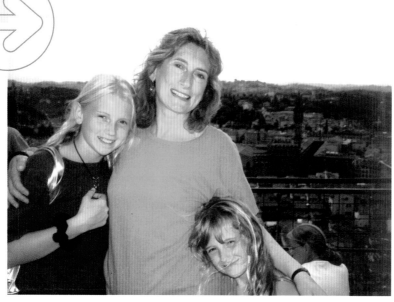

Although there are plenty of good color correction tools within Elements, none of them compares in strength to *Levels*. *Levels* will allow you to control the highlights, midtones, and shadows of an image using a visual reference called a histogram. When you're using *Levels* the histogram is simply a visual representation of the tonal makeup of the image. It might look complex, but the *Levels* dialog box is pretty straightforward for such a powerful tool. Beneath the histogram are three slider triangles that can be used to alter the distribution in the final image. For example, sliding the black triangle to the right by 10 units sets the 10 darkest shades of the image to black, and adjusts the others accordingly. Working toward the left does the opposite.

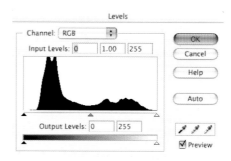

1 This picture looks flat and slightly lifeless. There are no true darks and the only highlight in the image is the white on the girl's purse strap. Make a *Levels* adjustment layer and take a look at the histogram. The *Levels* histogram shows that the shadows are not at their fullest. There is a gap on the left of the histogram where the dark tones should be visible. The highlights could probably be pushed until the sky blows out a little. The overcast day has affected the shot but it will look a lot better brightened up, with some color and detail in it.

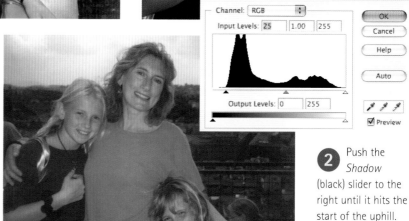

2 Push the *Shadow* (black) slider to the right until it hits the start of the uphill. This brings in some good darks and some details to the town in the background. It also darkens the image considerably.

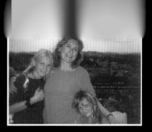
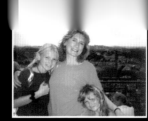

Photoshop Elements can show you the balance of tones in an image in the form of the *Levels* histogram. This makes it easy to select the right range to bring a dull image to life. You'll use this tool for many tone and color corrections.

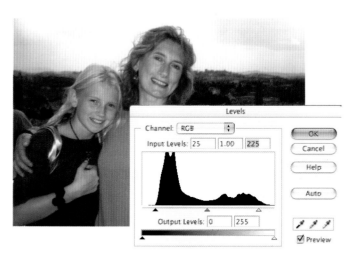

5 If the sky is not a serious issue, we can push the *Highlight* slider even further—all the way to 190. The detail in the sky is lost, but you gain detail elsewhere in the picture and the colors are now bright and clear.

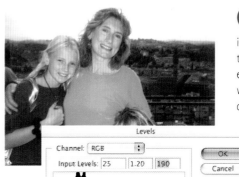

3 Pull the *Highlights* (white) slider to the left until a portion of the sky blows out. This should happen where the slider hits the trailing edge of the peak, affecting the sky to the left of the woman's head.

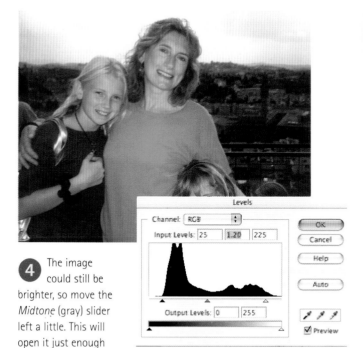

4 The image could still be brighter, so move the *Midtone* (gray) slider left a little. This will open it just enough to look better, without the darks going too gray. Overall, it's a big improvement.

TIP

Once you have finished and clicked OK, you can look at the new histogram by clicking *Image > Histogram*.

RECAP

A Lifeless
Use *Levels* to add life and tone to dark, overexposed or lackluster images.

B Shadow
Push the *Shadow* slider to the first slope of the histogram. This adds shadow tone and enhances detail.

C Midtone and highlight
Move the *Midtone* and *Highlight* sliders to brighten the image and keep the colors vibrant.

Levels

Most general exposure problems can be solved by clicking the *Auto* button and adjusting the three input sliders. There are some situations, however, when you need to get to grips with the rest of the *Levels* palette. The "eyedroppers" allow you to make changes by clicking on the areas in the image that correspond to the colors of the eyedroppers. The *Channel* pop-up menu allows you to choose whether your adjustments affect just one color channel or all of them. The composite channel affects all of them evenly—it will correspond to the type of image you have open.

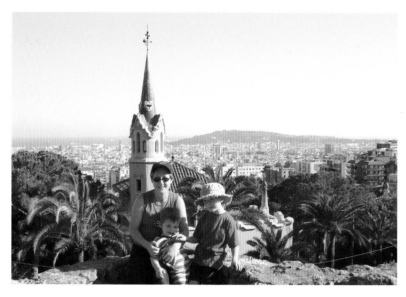

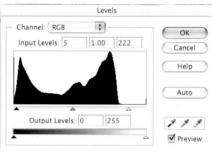

2 If we try the same style correction as we made to the image on pages 30-31 we get a definite improvement. But it still seems to have a coldness that doesn't feel right. The greens and the buildings have a blueish feel to them. We've brought out the sun, but not quite enough. Using the composite correction will only get us so far. It's time to go into each individual channel and tweak it.

3 Going into the *Levels* dialog box, adjust the composite *RGB* channel, moving the *Shadow* (left) slider to 5, and the *Highlight* (right) slider to 222. This introduces a slight contrast to the image. There is still quite a gap on the highlight end. This is going to be fixed by going into the individual channels.

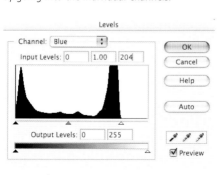

4 Select the *Blue* channel from the *Channel* menu and pull the *Highlight* slider to the left to 204. This removes some of the yellow cast.

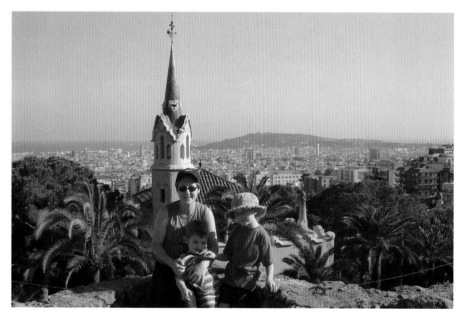

1 The shot of the family overlooking the church is dark and has a blue cast to it. Yet the sunspots on the people and the church steeple tell you that there was a good deal of sun when the image was taken. There is also a definite hazy cast to the shot.

Although most color and exposure problems can be solved using the *Auto* button, *Levels* allows you to make changes to individual channels in your image. This gives you the freedom and flexibility to experiment.

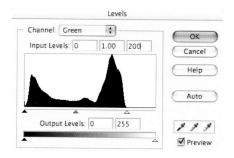

5 Now go to the *Green* channel and slide the *Highlight* slider to 200. This will remove the red cast introduced by the *Blue* channel adjustment.

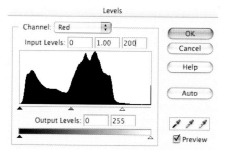

6 Finally go to the *Red* channel and move the *Highlight* slider to 200. This cleans up the green cast and also the haze that was there. The final shot appears similar to the previous fixed shot, but look closer and you can see deeper blues and a warmer overall cast.

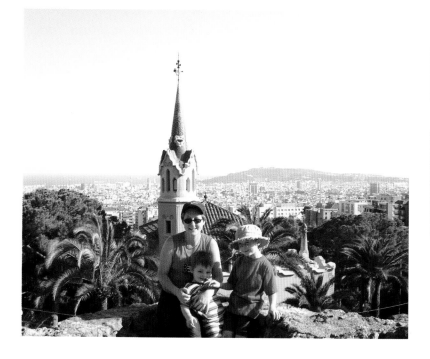

RECAP

Ⓐ Composite corrections
To fix this photo we made corrections to the composite channel which affects all three colors.

Ⓑ Remove cast
Going to the *Blue* channel and pulling the *Highlight* slider to the left removed some of the yellow color cast.

Ⓒ Fine-tuning
Adjustments to the *Green* channel got rid of the red color cast, while adjustments to the *Red* channel removed the green cast and the haze, adding deeper blues and warmer tones.

TIP
Holding down the Option key (Alt in Windows) while in any of these dialog boxes will change the *Cancel* button to a *Reset* button, allowing you to start again.

Correcting color

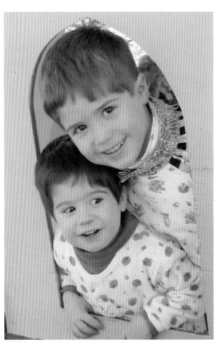

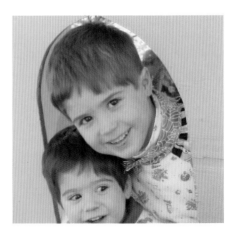

One of the most common problems you'll encounter in digital photography is incorrect color casts. These often occur when you are shooting photographs indoors, under artificial lighting conditions. To compensate for the problem, many modern digital cameras allow you to adjust white balance settings. There are, however, some occasions when color casts can only be fixed on the computer. Fortunately, image-editing programs make this task relatively simple to achieve.

Color Cast Correction

To Correct a Color Cast
To correct a color cast, click around the area of the image that should be gray, white or black.

OK
Cancel
Reset
Help
☑ Preview

1 We can start to fix this image by opening up the *Color Cast Correction* tool in Photoshop Elements (go to *Enhance > Adjust Color > Color Cast*). This will bring up a dialog box asking you to click an area that should be gray, white, or black. Do not try to pick all three—you will get some bizarre results. The multiple clicks can build upon each other, hence the handy *Reset* button.

TIP In Adobe Photoshop Elements and Adobe Phtoshop you can also use *Levels* to correct a color cast or add contrast. Remember to do these operations individually.

2 While we want the hair to be darker, we don't want it to be black—it's obviously brown in both cases. There are also no grays in the image, so we need to find something else that is definitely black or white. Clicking on the black checks in the cape works well for the flesh tones and whites by bringing in some necessary yellow to balance out the blue cast. However, it makes the wall a gray color, which we already know is wrong.

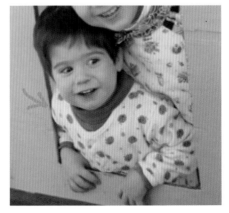

3 If we click on the brightest part of the white in the outfits, it not only gives us pleasant flesh tones, but also the pinkish/violet background. The whites are also without the blue cast, and the image looks a lot better. We have corrected the color cast and the image even seems to have more contrast to it. If you wanted still more punch use *Levels* to add more contrast at the shadow end.

Unwanted color casts can ruin a picture. Fortunately, most image-editing packages provide easy solutions for this problem. Adobe Photoshop Elements has a dedicated *Color Cast Correction* tool that is powerful and very easy to use.

TRIAL AND ERROR

What if you have a shot taken under fluorescent lighting or some other situation which has caused a bad cast? Perhaps you want to rescue an old yellowed picture? *Color Cast Correction* also works well there.

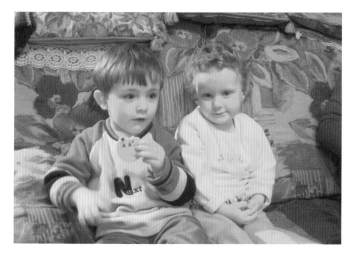

1 Take a look at this picture of two children on a floral chesterfield. The girl is obviously supposed to be wearing a white sweatshirt, while the boy's is black and gray.

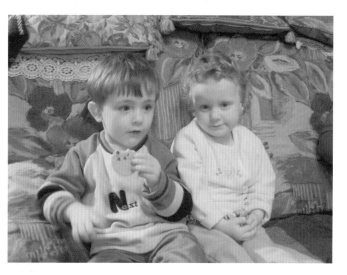

3 Click on the *Reset* button and try the gray part of the boy's sweatshirt. This gets rid of the yellow cast, but leaves the picture looking bluish. Click *Reset* and try clicking on some of the areas in the shot that you think are supposed to be black. Judging by some of the results you might get, it seems impossible to correct any color cast without creating a new one. Trial and error is the only way forward.

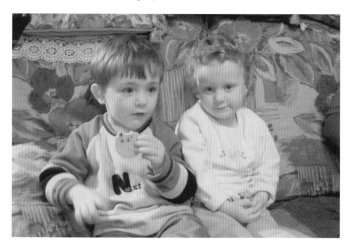

2 Launch the *Color Cast Correction* tool and click on the whitest area in the shot. This takes away most of the cast but not all of it. It also now leaves it kind of pinkish and a little on the flat side.

TIP Once you've got the hang of layers (see page 50) then it's a good idea to copy the original layer (called "Background") before you start.

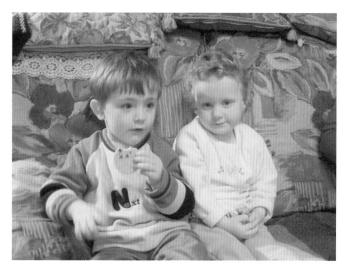

4 The best area for this shot seems to be under the pillow in the dark area right above the girl's head. This does have the color cast removed but has also added a cyan cast to the highlights. Launch *Color Cast Correction* again and click on the light-blue patch in the boy's shirt just to the left of the cookie. This is much better, but it's still not quite right. If we now apply *Levels* to the picture and adjust the *Green* channel (see page 32), we get a much improved shot.

Cropping

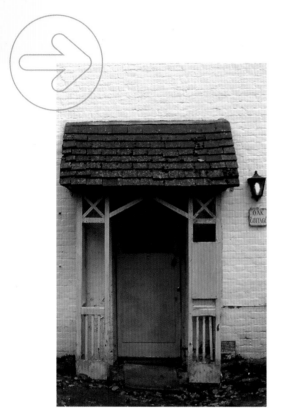

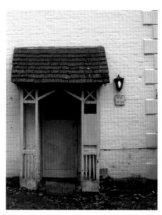

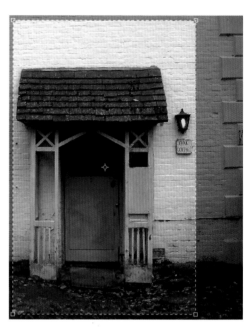

Having excess image around a subject of interest is sometimes unavoidable. Perhaps the angle of the shot was the best available at the time, or you just couldn't get close enough or use a zoom. In some cases, the shot could be a great one, but you only need a portion of it for a particular project. This is where the *Crop* tool comes into play. Not only does it allow you to trim away the parts of the image you don't want, but it also offers several options that will cut steps from a workthrough, such as resizing to a fixed size, rotating and cropping to a fixed proportion, or changing the resolution of the file.

1 We want to turn this photo of the blue door of a cottage into a 5 x 8 inch shot. If you just want to print the door, roof, and nameplate, and you want to print it at the same size, type 5 in the *Width* and 8 in the *Height* boxes. If it's best to output to your printer at 150 ppi, you can type that in too. Start the crop by clicking and dragging the crop marquee from any starting point, usually a top corner, and the dimensions will be fixed.

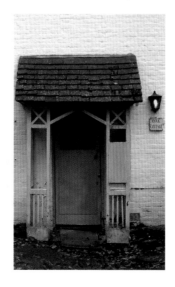

2 When you have completed drawing the crop, the chosen area is surrounded by a bounding box, and the area around it will be shaded. This gives you a preview of how the cropped shot will look. The color of the shading can be changed or turned off from the *Option Bar*. If you need to move the crop you can either click and drag from within the box or use the arrow keys to nudge it into place.

3 Once you are sure that you have selected the area you want, either hit the Return key, click on the green tick at the right-hand end of the *Option Bar*, or double click within the crop area. You should now have a cropped area enlarged up to a perfect 5 x 8 shot. If you want to cancel the crop, hit the Escape key or the *Cancel* button in the *Option Bar*. To remove the fixed proportions from the *Option Bar* click on the *Clear* button.

TIP You can also crop an image by selecting an area with the *Marquee* tool and choosing *Crop* from the *Image* menu.

Most image-editing software packages allow you to crop your images. Some, including Adobe Photoshop Elements, allow you to crop and rotate an image at the same time. This is a useful way of improving the composition of an image.

TWO JOBS IN ONE

Sometimes you might want to rotate your image slightly at the same time as you crop. In the shot of the little girl at the coconut stand the image is slanted down to the left. The red line clearly demonstrates this.

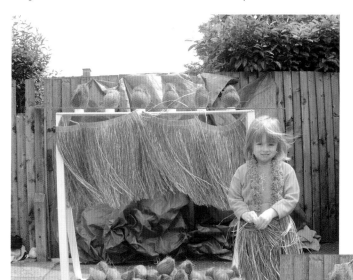

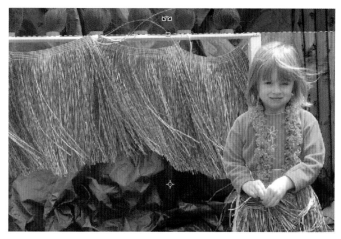

2 When you are happy with the crop, place your cursor outside the cropped area. It will turn into a curved line with arrowheads at each end. Click outside the crop area and drag to the left. The shaded area will rotate along with the movement.

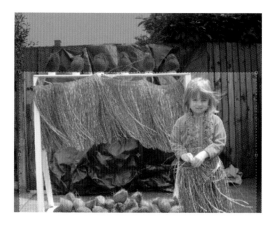

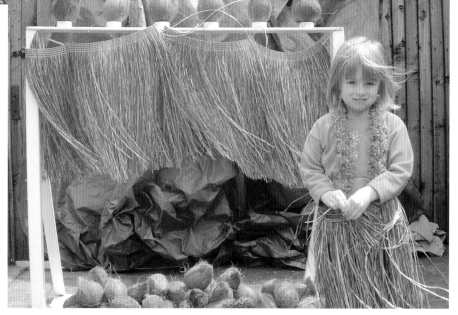

1 First, select the area that you wish to crop using the *Crop* tool. After you have selected the area, drag it down toward the top right corner of the white plank on which the coconuts are resting. Hold down the Shift key to stop the bounding box from moving diagonally as you drag.

3 When you think that you have the angle you need, use the down arrow to align the top of the crop area with the plank. Now, click within the crop area and drag the area up to where you want the crop to be. Again, hold down the Shift key so the bounding box only moves vertically. Once the bounding box is in place either double click within it or click on the check mark in the *Option Bar* to accept the change.

Rotating

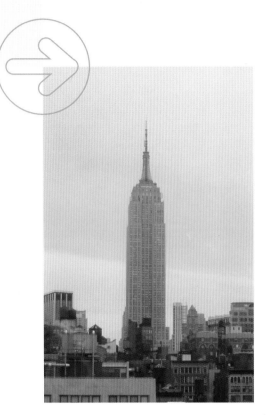

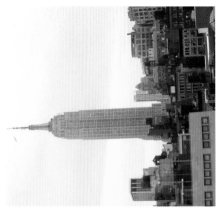

1 The image of the Empire State Building is not only rotated but also crooked. Straightening it in Elements takes several steps, but it is still comparatively simple.

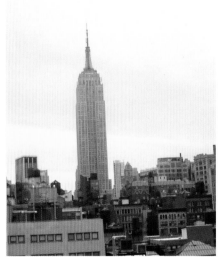

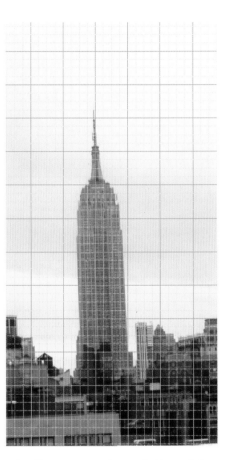

There are always times when we need to rotate the camera to get a shot to fit the viewfinder. Photoshop Elements offers a range of options that allows you to do this. The standard options are 90 degrees clockwise and counterclockwise, 180 degrees, and flip horizontal and vertical. Some programs allow you to measure the angle and type it in for precise movements, while Elements has a custom option that allows you to type in degrees. To access the *Rotate* functions go to *Image > Rotate*. You will find a comprehensive list of what can be achieved with this tool.

2 You could go ahead and try the *Straighten Image* option, but the resulting image usually won't be perfectly straight. The easiest way of rotating the image is to use the 90 degrees to the right option, but even then it's still not quite right.

TIP Don't straighten large, multilayered images until they have been flattened. Bigger files take longer to process.

3 Some programs have a *Guides* or *Rulers* option which you can use to measure precise angles, but in Photoshop Elements you can also use the *Grid* option, by selecting *View > Grid*. A number of black and white lines will appear over the image in perfect horizontal and vertical alignment. You can change the appearance and the color and placement of the grid in *Preferences*.

4 We don't want to rotate the line when we straighten the image but we

can't rotate a background layer. What we have to do is make the layer movable. To do this, press Option (Alt in Windows) and double click on the word *Background* in the *Layers* palette. This will change it to *Layer 0*, a movable layer.

There is no need to worry about getting an image perfectly straight when taking a digital photograph. You can use your image-editing program to straighten it automatically—or manually for more tricky images.

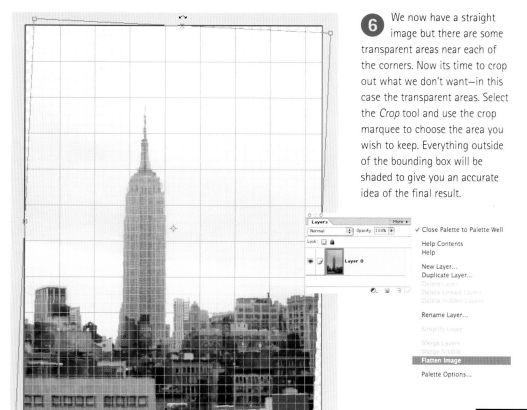

6 We now have a straight image but there are some transparent areas near each of the corners. Now its time to crop out what we don't want—in this case the transparent areas. Select the *Crop* tool and use the crop marquee to choose the area you wish to keep. Everything outside of the bounding box will be shaded to give you an accurate idea of the final result.

7 After you have chosen the area you want, simply double click within the area to accept it. Incidentally, for both the rotation option described earlier and the *Crop* tool, if you make a mistake before accepting the change just hit the Escape key to cancel it. After cropping, flatten the image and save it.

4 Under *Image > Rotate*, there is an option entitled *Rotate Layer* (although you could also use the *Free Transform* command: *Image > Transform > Free Transform*). This will place a bounding box with eight control points around the perimeter of the layer. Placing your cursor near one of these points changes it to a curved double-headed arrow. In the center of the bounding box is a cross with a circle overlaid above it. This is the pivot for the layer.

5 Begin by clicking and holding your cursor near any of the control points and dragging clockwise. This should get you exactly where you want to go, or close enough. Fine-tuning the movement can be done via the *Set Rotation* box in the *Menu Bar*. Click once inside it and use the up and down arrows to complete or undertake the entire rotation. As you can see, the building is getting straighter. If you find it gets too far from a grid line, use the arrow keys to nudge the building over. Make sure that you count how many times you press the arrow key to nudge it so you can nudge it back after finishing the rotation.

FACT FILE

Guides

Althought not available in Photoshop Elements, many programs (including Photoshop itself) have an easy-to-use guide feature. To use it, simply make the rulers visible (Command-R or Ctrl-R in Windows) then click on a ruler and drag a guide line from it. You can place guidelines anywhere on an image, move them around using the *Move* tool, and hide/view them using Command-H (Ctrl+H in Windows).

Sharpening

Before sharpening

Sharpen

Sharpening an image can make details emerge from an area that previously had none. The *Sharpen* tool is a useful one, but you need to be careful—it's all too easy to oversharpen. Most programs have several ways to sharpen images. Both Photoshop and Photoshop Elements have a regular *Sharpen* filter with a set strength of about 3 pixels. This is fine if you want to see a subtle difference and don't wish to be bothered with a dialog box. On images with few sharp edges or little detail, though, you may barely notice the difference. For these, there are other ways to sharpen.

The Sharpen *tool is a quick, one-stop sharpen, but its effects are limited. If your image still has a fuzzy look, you can repeat the* Sharpen *filter, or drop one step down to* Filter > Sharpen > Sharpen More.

Sharpen more

SHARPEN MORE

Sharpen More is similar to *Sharpen* in that it has no dialog box. It is also in most applications and has a sharpen radius that is about 5 pixels. This is accessed by going to *Filter > Sharpen > Sharpen More*. On low-resolution images this will seem like a huge amount, and even on high-resolution images you will notice the change right away in areas like hair. You should also keep an eye on faces: any hard edges around the eyes, mouth, or nostrils can quickly become very noticeable.

UNSHARP MASK

The best option for sharpening is the *Unsharp Mask* filter, as it is the only one that gives you full manual control over the effect. In Photoshop and Photoshop Elements it is accessed by going to *Filter > Sharpen > Unsharp Mask*. The dialog box for this has three control sliders on it as well as a preview window, and the preview window has a + and a—button that you can click on to enlarge an area to see the effect better. You can move the area seen in the preview image by clicking in it with the cursor.

Although no substitute for good focus when taking the photo, digital sharpening can really improve an image. These filters enhance areas of close contrast according to your preferences.

For real control, the best option is the Unsharp Mask. Begin by fixing the Amount *(200 is a good start) and then move the* Radius *to suit the image (start* at the default, then move up or down and watch the effect). Only push *the* Threshold *up if there are areas of low contrast, particularly skin.*

Before

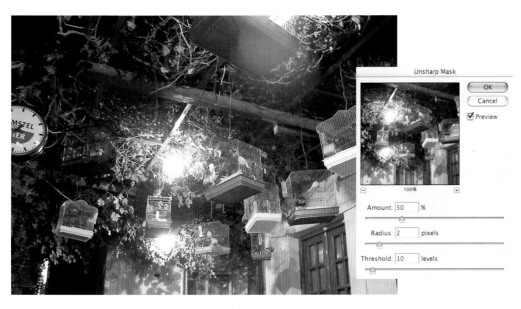

Effective use of the Unsharp Mask

After

The top slider is the *Amount* slider, which has a range of 0 to 500. This tells the filter how much to sharpen the image. The higher the *Amount*, the greater the degree of sharpening, but overdoing it can give areas of the image an ugly, granular look.

The next slider, the *Radius*, controls the number of pixels in a radius that you wish the filter to use for its calculations. The numbers here go from 0 to 250 with the ability to go up and down by .1. Again, going high has its downside—harsh outlines that you might not want. These dark and white outlines against hard edges not only make the sharpening show, but also can detract from the image.

The last slider, the *Threshold*, controls the amount of the original image used as a mask to keep the sharpening effect in check. The numbers here are 0 to 255 with zero being the value to let all of the filter through and 255 to stopping the filter entirely.

Misuse of the Unsharp Mask causes its own problems. With high Amount *and* Radius settings, and no use of the Threshold to protect low-contrast areas, you can get some ugly results.

Too much Unsharp Mask

ANOTHER WAY

Sharpening can be more effective if only applied to specific areas of an image, in which case the *Sharpen* tool is the feature to use. This tool allows you to brush on sharpness only where you need it. You can also use blend modes (see p46) to good effect. Try using the *Luminosity* blend mode: as it leaves the color alone it tends to cause fewer jaggies and other artifacts than regular sharpening. ("Jaggies" refers to the stepping effect that occurs when pixel patterns in an image become noticeable—sometimes as a result of oversharpening. Look at the cat's face in this example.)

3 Retouching tools and techniques

The first thing to understand about retouching is that nothing is set in stone. No single technique is the be-all-and-end-all way of doing something, especially with software as feature-packed as Photoshop. There may be a dozen ways to achieve a great end result, or solve a specific problem. This section shows you how to use the various tools and techniques for basic retouching, then goes on to show you some methods and effects that can really polish and sell an image.

Dust removal

Even the most careful photographer has to deal with dust and scratches from time to time. Whether you scan a transparency, a negative, or a print, you'll find that unwanted marks are hard to avoid. Removing marks from dirt and damage is one of the basic retouching skills. When repairing a photo it is rarely enough just to place flat color over a blemish. Unlike most computer-made graphics, photos are filled with subtle tonal changes, grain, and other detail that makes even nominally flat color anything but plain. The first and most obvious tool to turn to is the *Clone Stamp* tool. With this, you can paint snippets of one area of an image over another.

1 This scanned photo clearly has some areas that need to be cleaned up. Choose the *Clone Stamp* tool from the *Toolbox*, then use the *Options Bar* to select your brush size. If you set its *Opacity* to 80% or 90%, this will help your retouching work blend smoothly with the original, but watch out for a subtle blurring of textures as you paint.

2 The *Clone Stamp* tool paints one part of the image onto another, so you first have to pick where to sample from. Option-click (Alt-click) a similar area of the image, being careful to match both the general hue and the brightness of the area you plan to repair. When you start to paint over a flaw, you will pick up from your source area, painting a patch of image over the damaged area. Look out for changes in the image, and be ready to Option-click (Alt-click) to set a new source. This avoids an obviously patched-up result.

3 The *Options Bar* holds the standard options for choosing a particular brush size and opacity, but there is also a checkbox called *Aligned*. With this on, the relative position between the clone source and the brush is always the same. With this off, each time you stop painting, the clone source point picks up from the original point again.

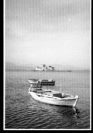 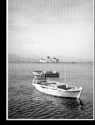

Marks made by dust and scratches can be removed automatically by your computer, while still preserving the grain. Larger marks can also be wiped away in just a couple of clicks.

4 If your image has a lot of dust and dirt marks, the *Dust & Scratches* filter can save you a lot of time. This filter looks for small, sudden changes in brightness and contrast in the image, and fills in those marks with color from the surrounding area. Go to *Filters > Noise > Dust & Scratches* and move the preview area over to an area with unwanted marks, and see how the default settings work.

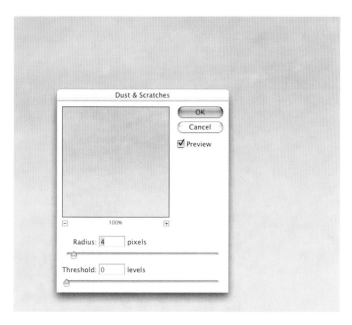

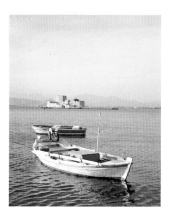

6 Using a combination of the tools and methods shown you can create a scanned shot that's free from dust and scratches, but without losing all the detail in the image.

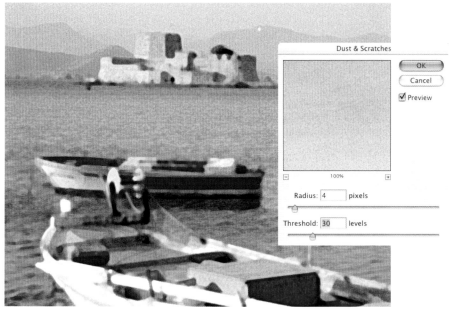

5 The best results will come when the controls are adjusted to suit your image. The *Radius* slider controls how large an area will be affected; a larger setting means bigger marks will be tackled. However, as seen in the previous image, when used on its own it can be too heavy-handed. The *Threshold* slider helps protect subtle grain and texture in the photo. Here, bringing the *Threshold* setting up to 30 preserved the photo's natural grain, and setting the *Radius* to 4 eliminated all the smaller defects. Original detail can be decimated by this filter with even small radius changes, so working within a selection rather than on the whole image is best.

FACT FILE

Brush tools
The *Clone Stamp* tool, like many in Photoshop Elements, is a brush tool. All these tools share the same basic set of brushes and options, accessed from the *Options Bar*, and a few useful keyboard shortcuts. To make the brush head smaller or larger, for example, click either the [or] keys. Pressing *Shift* at the same time changes the hardness of the brush.

You can also get better results from these tools by getting a pen or graphics tablet, which are pressure-sensitive, and cost little more than a new mouse.

Selection tools

You can achieve a lot in Photoshop Elements by making adjustments to the image as a whole—but to really get the most from the program you need to learn how to make selections. Only by choosing specific parts of your image to reshape, reposition, or adjust can you get to grips with the program's real image-processing power.

TIP You can add to or subtract from a selected area by pressing Shift or Option (Alt) as you use the tool.

The Marquee *tools*

In Photoshop and Photoshop Elements you have two basic selection tools—the *Marquee* and the *Lasso*. Each has its own, specialist variations. The simplest is the *Rectangular Marquee*, which makes a square or rectangular selection box. Its close relative, the *Elliptical Marquee*, makes a circular or oval selections.

The default is the *Rectangular Marquee*. To get to the *Elliptical* tool, you need to do one of two things. Either click and hold on the *Marquee* tool in the *Toolbox* until the flyout appears, or just Option-click (Alt-click) on the tool. Both tools have much in common. Firstly, you can soften the edges of either selection by adding a number to the *Feather* box in the **Options Bar**. Add a 10-pixel feather, for example, and the pixels in a 5-pixel area around the selection will be partially added to your selection. This is particularly useful when you want to blend in an adjustment.

You can also constrain the shape of your selection, either to a perfect square or a perfect circle, by holding down the Shift key as you draw. If you hold down the Option key, meanwhile, the square or circle will be drawn from the center point. If at any point you decide that you need to move the selection while you are drawing just hold down the

The Lasso *tools*

spacebar and move it to where you want it. Then release the spacebar and continue drawing. After drawing any selection you can move it elsewhere by clicking and dragging within.

The basic *Lasso* tool allows you to select any shape. If you have a steady hand and use a drawing tablet, this can be very useful for isolating objects that are nonsymmetrical. Once you have started drawing with the freeform *Lasso* tool you need to hold down the Option key. Otherwise when you stop drawing and release the mouse button the selection will automatically connect the ends of the selection. If your hand isn't quite so steady, reach for the *Polygonal* lasso. Using this you can create selections by clicking from point to point to create a series of straight lines, which you finally double-click to join together, thereby enclosing the selection.

It's a mistake, however, to think that the *Lasso* does freeform shapes, while the *Polygonal* can only do straight lines. If you use the *Polygonal* tool and need to make a curve in the middle of the selection, press and hold the Option key. The same thing works the other way around, toggling the *Lasso* to *Polygonal* mode so you can draw a straight line.

Selelcting areas of your image for individual attention is another key element of most digital image correction. The *Marquee* and *Lasso* tools tackle this problem by letting you draw shapes or lines around your target area(s).

THE MAGNETIC LASSO

The *Lasso* has another useful variant—the *Magnetic Lasso*. This intelligently selects objects from their surroundings by detecting their edges. It's generally used when there are high contrasts between the object you're trying to select and the background. There are three settings in the *Options Bar* that you need to think about: the width of the *Lasso* brush, the *Edge Contrast* setting, which controls how much the edge must contrast from its surroundings before it's selected, and the *Frequency*, which controls the number of "anchor points" that control the selection.

① The *Edge Contrast* setting is the most important. If set too low, the *Lasso* ends up selecting unwanted material. If set too high, it might not find anything at all.

② As a result, using the *Magnetic Lasso* always involves some trial and error, but you can help it along by adding your own anchor points around tricky shapes or difficult corners. Just click where you want to add one.

③ If your mouse slips and the *Magnetic Lasso* runs away with itself, you can remove anchor points by pressing the Backspace key.

④ Increasing the *Frequency* setting can also help. Low frequency (top) creates a smooth, but inaccurate, selection. Increasing the frequency (above) adds anchor points, and keeps the selection under tight control.

Making selections

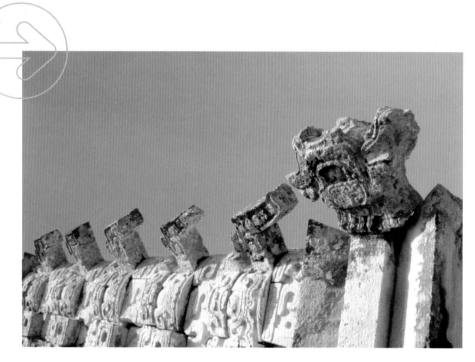

TIP To quickly invert a selection use the Command-Shift-I shortcut keys (Ctrl-Shift-I in Windows).

Making selections can be a tedious process, even with the help of the *Magnetic Lasso*. Sometimes, however, there's a better way. Instead of selecting objects by shape, it sometimes makes more sense to select them by color and hue; an approach that can be more efficient—and more precise—than laboriously tracing the selection with the *Lasso*. The first tool that most people go to in these circumstances is the *Magic Wand*. This seeks out similar colors to whatever you have clicked on. The *Option Bar* gives you the choice of whether it selects colors that are adjacent (contiguous) to where you click, or similar colors in the entire document.

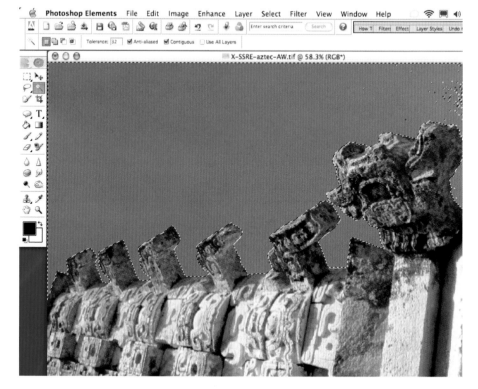

① In this photo of some ancient Aztec statues we'll use the *Magic Wand* to select the sky. As with the *Polygonal Lasso* and its *Edge setting*, the *Magic Wand* usually needs a little trial and error to get the *Tolerance* right. With the *Tolerance* set to 32, click on an area of sky. As you can see, it doesn't select all of the blue in the image.

When drawing around objects seems impossible, the *Magic Wand* can help out. It works by selecting areas of similar color, making it fabulous for selecting skies and backgrounds.

2 Hold down the Shift key and click in one of the darker blue areas to add them to the selection. As you can see, this gets more, but still not all of the blue. Raise the *Tolerance* to 50 and Shift-click again.

3 Keep clicking and changing the *Tolerance* until you have the blue areas selected. You can also use the *Lasso* tool to subtract from the selection, by holding the Option (Alt) key down, should you run over into an area you want to keep.

Tolerance: 50 ☑ Anti-aliased ☑ Contiguous ☐ Use All Layers

4 The blues are almost all selected now. There are still some areas that need to be selected where the sky is visible through gaps in the statues. While you might be able to select these by using the *Magic Wand* with the *Contiguous* option unchecked, it's quicker to select these with another method.

5 In this case, we'll use the *Selection Brush*. This allows you to make a selection in two ways. It will create a selection or it will make a red overlay that you can brush onto or take away from. To add to the selection just paint. To subtract hold down the Option key. To select the heads simply invert the selection—*Select > Inverse.*

Layers

Photoshop's Layers feature is one of the most powerful in the program. Understand how to use it and you will never look back. Layers act like the sheets of acetate used in traditional animation, stacking on top of each other to create a composite image. By assigning or copying different parts of an image to separate layers, you can do some amazing things. Not only can you mix and match parts of images with amazing flexibility, you can also adjust or manipulate layers on an individual basis, protecting the original image and leaving you free to change your mind later. Layers can be switched on, switched off, duplicated or deleted at will, made transparent, or combined in a variety of different ways. The effects can be spectacular.

If you want to make a localized correction within a selection, you can put this on its own layer. After you have made the selection, go to *Layers > New Layer > Copy to New Layer*. This puts the selection on a separate layer, surrounded by transparency. You can paint away anything that you don't want with the *Eraser* tool, and even soften the edges with feathering if the selection wasn't feathered before it was moved to the new layer.

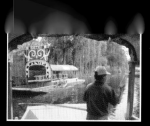
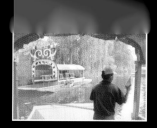

Perhaps the most versatile feature of Photoshop is its use of layers, which allow an amazing degree of flexibility. Layers let you do to your images what acetate did to animation—move, blend, adjust coloring, and more.

To move the object around on its layer, use the *Move* tool, clicking and dragging it into position. For quick access to the *Move* tool, hold down the Command key (or Ctrl in Windows) while another tool is active. As you do so, you can also nudge the object around with the arrow keys.

ADJUSTMENT LAYERS

If you are making a color change to the image or a portion of the image, you can use what is called an adjustment layer. This is a nondestructive way of editing colors and tones, just as you would with the *Image > Adjust* menus, but without affecting the original pixels. Even better, adjustment layers can also have masks attached to the layer, enabling you to limit a correction to specific areas. The masked area can be changed later if necessary. You can alter masks with any selection tool or even use the paintbrush to change specific areas with controlled brushes. Nothing is set in stone; the results are infinitely flexible.

THE LAYERS PALETTE

Change the *Opacity* of Layers using the *Opacity* slider. You can have transparent layers with *Opacity* ranging from 0 all the way to 100. This helps when blending objects, and can lead to great effects.

Use the eye icons to toggle layer visibility on and off. You can see changes made to layers by turning them off and on, and looking at the original background. Click on a layer to select it for work, or drag it up and down in the palette to change the layer order.

In Elements and Photoshop, you can make a duplicate of any layer, including the background layer, just by dragging that layer down to the icon at the bottom of the *Layers* palette that looks like a page.

Layers can be locked in two ways to protect them: by locking the transparency so that a filter cannot fill it in, or by locking the layer itself so that nothing can be done to it at all.

Blend modes

To make *Layers* even more dynamic, you have the option to change the way in which layers blend with one another. There are 22 different blend modes, and by using these you can achieve some very interesting and complex color effects. Combine blend modes with *Transparency*, and it's possible to pull up detail where there is very little, or dramatically change the mood of a shot.

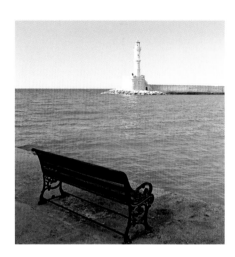

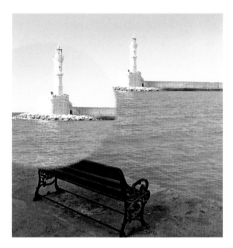

1 NORMAL: The first and most basic of the blend modes. One layer sits on top of another, and there is otherwise no interaction between the two.

2 DISSOLVE: The two layers combine in a random pixel pattern. The effect on the top layer is determined by its opacity. If high, the layer may be unaffected or it may be broken up around the edges. If low, the effects are more pronounced.

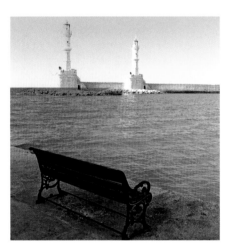

3 DARKEN: The color of the pixels in the top layer is applied to the layer beneath in areas where they are darker. Where the pixels have the same or lighter color value as the layer below, there is no change.

4 MULTIPLY: This blend mode takes the pixel values in the two layers and multiplies them, raising the density. Using *Multiply* is a great way to add tone to very light areas without undertaking any color correction. *Multiply* has no effect on white areas, but can darken black areas excessively.

5 COLOR BURN: This uses the colors of the top layer to darken the colors of the layer underneath.

Using layers and blend modes is an excellent means of adding contrast or depth to an image. They can also generate special effects that transform the appearance of a digital photograph.

6 LINEAR BURN: This works like *Color Burn* but with a greater effect on the pixel brightness. The result is a much darker blend that affects lighter areas more.

7 LIGHTEN: The opposite of *Darken*. Wherever the pixels on the top layer are lighter than those below, they lighten them. Wherever they are the same or darker, there will be no change.

8 SCREEN: A blend mode where the color values of pixels in the top layer are inverted, then multiplied with those of the layer below. With any color besides black, the result is always a lighter image, making this a great blend mode for opening up dark images.

9 COLOR DODGE: The opposite of *Color Burn*, brightening the image while blending colors in the top layer with colors in the layer beneath.

10 OVERLAY: Retains black and white tones in their original form but darkens dark areas and lightens light areas, making it a useful way to add contrast to your image. Simply duplicating the image to its own layer will move the shadows and highlights while keeping the midtones almost untouched.

10ª If you use a tint on its own layer and set the blend mode to *Overlay* it will try to hold the shadows and highlights while blending in the color.

TIP Altering the *Opacity* level of a layer can dramatically enhance an effect. Experiment with the settings to see this in action.

Blend modes

11 LINEAR DODGE: This blend mode works in the same way as *Color Dodge*, except that it removes more color as it brightens.

12 SOFT LIGHT: This mode also adds contrast to an image (although not as much as *Overlay*). Anything under 50% gray in the blend color will lighten the image and anything over 50% gray will darken it.

13 HARD LIGHT: This is the same as *Soft Light* except that using black or white as a source color will result in a pure black or white in the image, giving a stronger, harsher, overall result.

14 VIVID LIGHT: Works in the same way as *Dodge* and *Burn*. Anything less than 50% gray is made lighter by lessening the contrast. Anything over 50% gray is darkened by increasing the contrast.

15 LINEAR LIGHT: Another member of the *Dodge* and *Burn* family. Anything under 50% gray is lightened by increasing the brightness. Anything higher than 50% gray is darkened by decreasing the brightness.

16 PIN LIGHT: This replaces colors depending on the color in the top layer. If the source color is lighter than 50% gray, anything darker will be replaced and anything lighter will be unchanged. If the source color is darker than 50% gray anything lighter will be replaced and anything darker will be unchanged. If you duplicate part of your image and put it on its own layer, and then change the blend mode to *Pin Light,* there will be no difference between the two.

There are 22 blend modes in total. Some change the appearance of the digital image radically, while others bring about a more subtle transformation.

17 DIFFERENCE: This changes colors depending on the color with the greater brightness value.

18 EXCLUSION: A variant of *Difference*, but with less contrast.

19 HUE: Uses the hue of colors in the top layer, while retaining the saturation and luminance of the target image beneath it.

20 SATURATION: Uses the saturation values of colors in the top layer, but mixes with the hue and luminance values of the lower image.

21 COLOR: Blends the hue and saturation of colors in the top layer with the luminance values of the image underneath.

22 LUMINOSITY: Uses the luminance values of the top layer with the hue and saturation of the image underneath.

TIP Duplicating a layer and using the *Screen* blend mode is a good way of increasing contrast in an image.

Blend modes

Dodge and burn

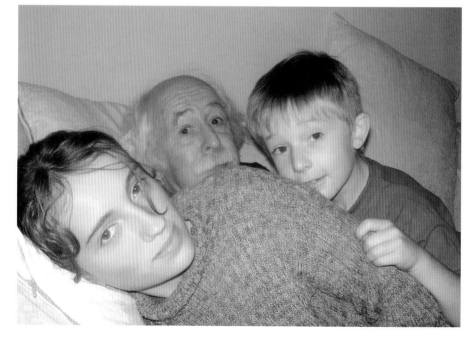

At times you shoot an image that looks almost complete: it has beautiful balance, the color is rich, and the camera has caught everything, just as it should do. Then while assessing the photo you can't help thinking, "this bit could be a little darker" or "how about a little contrast here?" You could make *Levels* or *Hue/Saturation* adjustments with selections and masks to constrain the effects, but there is a much easier way to work. Most imaging applications, including Photoshop and Elements, have *Dodge* and *Burn* tools that mimic their darkroom counterparts. These are powerful but easy tools to use.

1 In this picture, the boy's face and arm would benefit from more contrast. The *Burn* tool is ideal for this kind of work. Since we are looking to burn in some contrast, set the tool to work the *Midtone* and with about 30% strength. One thing to keep in mind is that these tools accumulate—the more you go over an area, the darker or lighter it will get.

TIP Use a pressure-sensitive graphics tablet to refine your control over the *Dodge* and *Burn* tools.

RETOUCHING TOOLS AND TECHNIQUES

Traditional photographers will be familiar with the techniques of dodging and burning. There are easy-to-use tools that simulate these powerful effects in both Photoshop Elements and Photoshop.

2 Select the *Burn* tool, and move it once over the boy's face. This adds color and contrast to the nose and eyes. Now switch to the *Shadow* setting and swipe along the side of the cheek. This gives some life and depth to the side of the face. Using the *Highlights* setting, brush up and down the boy's hand. You will need to adjust the strength setting for this. Having the *Highlights* setting at 30, for example, will burn in quite a bit of black. Try the same moves on the girl's face to bring out the lips and eyes.

3 The man's face is a little full and ruddy. Using the *Dodge* tool, lighten his face a bit around the nose area and then move up to the forehead. The bigger the brush you use, the easier it is to avoid overlapping strokes.

4 The only downside of this method is you might affect areas that you had not intended to change. A nice feature with these tools is that if you press the Option (Alt) key it will temporarily convert to the opposite tool. So *Dodge* becomes *Burn* and vice versa. The switch will also use the same setting, so if you inadvertently brush over the wrong area there is no need to waste a trip going to the *Toolbox*, and risk losing track of your work.

BROAD STROKES

With a nice big brush it is possible to quickly lighten or darken, add contrast, or just accentuate very large areas quickly without resorting to more complicated features. Notice how in this ocean image a few brush strokes can completely transfrom the appearance of a picture. It's all very quickly and artfully done.

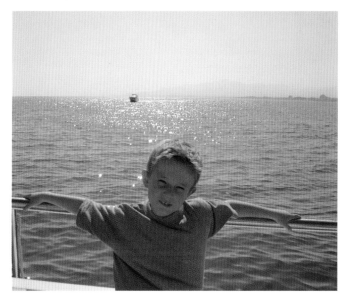

Before

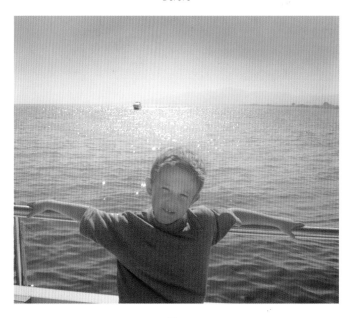

After

Using *Color Dodge* and *Color Burn*

1 The *Color Dodge* blend mode brightens an image when you layer one copy of it over another. Take this image of two girls hugging—as you can see, it looks a little flat and dull. Open it up in Photoshop, and duplicate the layer by dragging it down to the create new layer icon.

Partly because blend modes always lend themselves to more obvious creative transformations, even experienced Photoshop professionals can neglect their potential for adding more subtle effects of tone and contrast. By duplicating the background layer (or another layer) and applying *Color Dodge* or *Color Burn* (*see pages 52–53*), you can quickly add to the tonal richness of an image. You can also get similar effects if you apply the same blend modes to a *Color Balance*, *Brightness Contrast*, or *Levels* adjustment layer. Not only do you get the benefit of opening or darkening an image quickly, but you can also throw in a quick color fix.

2 Next set the blend mode to *Color Dodge*. As you can see the image brightens dramatically. So much so that the highlights of the girls' hair is overexposed. Additionally, however, increased contrast has helped add some depth and the slight blue cast has been removed.

Creating new layers and applying *Color Dodge* and *Color Burn* is an excellent way of adjusting your digital photographs. Using this method has the advantage of enabling you to fine-tune images without creating masks.

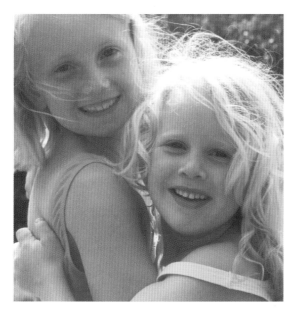

3 To fix the lost highlights, lower the *Opacity* of the layer until the detail returns. As you can see, you will need to adjust the opacity down to about 35%. The downside of this is that it also takes away a lot of what the blend mode achieved.

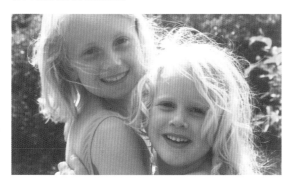

4 One way of fixing this would be to add a *Color* adjustment layer above it to try to get that level of contrast back. But you can save time and effort by adding a *Levels* adjustment layer on top, throwing away the duplicate layer, and setting the adjustment layer's blend mode to *Color Dodge*. Go to *Layer > New Adjustment Layer > Levels* and set the blend mode from the menu. Once you hit the *OK* button, adjust the levels to get the contrast back and also take care of the color balance. Using the blend mode makes the adjustment quicker and easier than it would be using *Levels* alone.

COLOR BURN

I used the same method with the harbor shot, but this time using *Color Burn*.

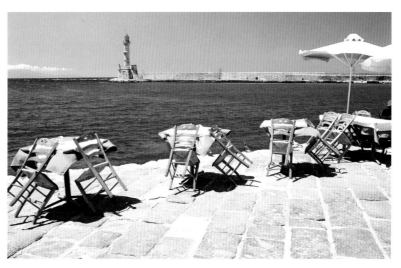

1 This image has enough contrast in it but the flagstones in the foreground could use some weight to them to create definition and detail. *Color Burn* will bump up the density of the image without changing the color too much, so long as you remember to keep the *Opacity* down.

2 Again, create your *Levels* adjustment layer and bring out the tones to your satisfaction. Here we are trying to add density without making the blues overbearing. If necessary, it is possible to resort to a *Hue/Saturation* adjustment layer afterward.

Blur effects

GAUSSIAN BLUR

One of the more sophisticated *Blur* filters is *Gaussian Blur*. With its adjustment slider and preview window, this filter can be used to soften just about everything you can think of: skin, dirt spots, even a whole image.

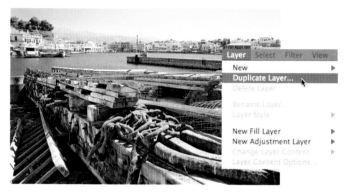

1 Open up the image and duplicate the *Background Layer*. It's a good idea to use filters on a copy of the original image layer. Doing so means that you can always delete the layer later and remove the effect. Lower the *Opacity* of the layer to fade the effect in or out—or use blend modes to modify it.

ven with colors adjusted and contrast added, some images still need a little extra help. There is some truth to the idea that simply adding an effects filter is the lazy way forward—and the results can be ugly or overbearing if an effect isn't handled with care. There are times, however, when they add just the right touch. The trick is to think about what you want to do to your photograph, and then browse through the *Filter* menu or the *Filter* palette and find the effect that will do the job. The *Blur* filters are probably the filters used most in the whole Photoshop collection. The basic *Blur* filter works adequately on smaller images, but on anything larger the results are almost unnoticeable. There are, however, a number of more advanced alternatives.

2 Launch the *Gaussian Blur* filter by selecting *Filters > Blur > Gaussian Blur*. Shift the level of the blur up to 2. This blurs the image so that it is not so sharp on the eyes that you cannot really focus on anything in particular.

3 If there is something that you want to focus in on, you can use the *Eraser* tool or the *Lasso* tool to isolate that section on the new layer and delete it. This allows the sharper image behind to show through.

The *Blur* filters are probably the most commonly used filters. They are particularly useful for creating an out-of-focus background so that the eye is drawn to an object in sharp focus.

RADIAL BLUR

Another *Blur* filter is the *Radial Blur*. This brings anything centered within that blur into extreme focus. The *Radial Blur* provides two different kinds of blur and several options for each. The first is *Spin* blur—this blurs the area around the center focal point in a spinning motion, so that the central region resembles stirred liquid, while the outside regions start to rotate. The second is *Zoom* blur—this zooms into the central area, giving an impression of motion. Both blurs share common controls.

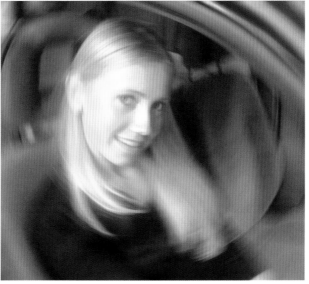

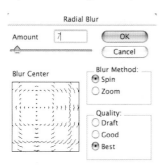

1 Open up your image and, as usual, duplicate the *Background* layer.

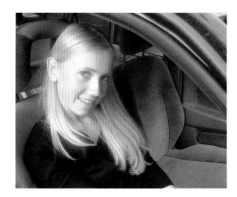

2 Launch the *Radial Blur* filter by selecting *Filters > Blur > Radial Blur*. Set the *Blur Method* to *Spin*, the *Amount* to 7, and the *Quality* to *Best*. Before hitting *OK*, take a look at the preview window. This displays groups of lines that graphically represent the center of the blur. If you click and drag the center you can position the effect where you think it is best placed.

3 This filter can take time to redraw, so if you want a quick preview of the effect, set the *Quality* to *Draft* and click *OK*. Once you're happy with the effect, go back to the menu and check the *Best* setting under *Quality*.

4 While the file is open, either throw away the *Background copy* layer or make a new copy of the *Background* layer and place it at the top of the *Layers* panel. You can do this by either dragging the layer to the top or by hitting the command-Shift-] keys.

TIP Try to use the Blur filters sparingly—it is far better to apply a blur several times in gentle increments.

5 Launch the *Radial Blur* filter again. Change the *Amount* setting to 15, the *Blur Method* to *Zoom*, and *Quality* to *Best*. Again, you can select the focal point by dragging the center of the lines to the desired spot.

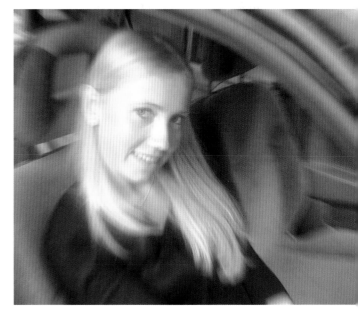

6 As you can see, the *Zoom* variant of the *Radial Blur* has a softer impact, yet it still draws your attention to the focal point very effectively.

Blur effects

MOTION BLUR

The last of the popular blurs is the *Motion Blur*, which emulates a fast motion captured on film. This filter is very rarely, if ever, used on an entire shot. The filter sports a zoomable preview window, a slider control for the direction or *Angle* of the blur, and a slider for the *Distance* that the blur extends to.

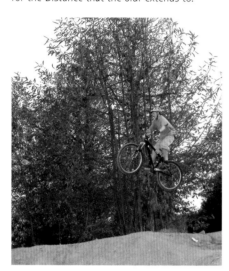

1 First, use the *Marquee* to make a rough selection around the boy on the bike, then place him on his own layer by selecting *Layer > New > Layer via Copy*. This doesn't have to be a huge selection.

TIP ➡ An alternative effect is to select a subject and copy to a new layer, then blur the whole background.

2 Turn off the visibity of the *Background* layer and use the *Eraser* tool to clear as much of the space around the bike as possible. This doesn't need to be exact—just go around and don't worry about the tricky areas in between the spokes. Duplicate this "silhouette layer" by dragging it on top of the paper icon at the bottom of the *Layers* palette, then turn off the visibility of the layer by clicking on the eyeball next to it in the *Layers* palette.

3 Select the first silhouetted layer and launch *Motion Blur* by selecting *Filter > Blur > Motion Blur*. Set the *Angle* to −23 so that it matches the angle of the boy flying through the air. The motion blur only makes sense when it follows the direction of movement. Change the *Distance* to 48, then hit *OK* (the higher the resolution, the more distance you will need to set).

4 This should blur the entire figure of the boy and the bicycle. If the shot looks fairly realistic to you, go ahead and use it. If not, undo the filter and try it again with a different setting.

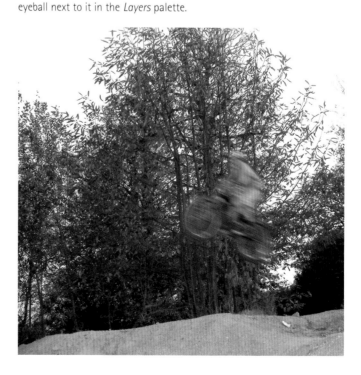

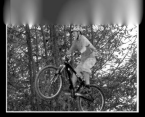

The oft-neglected *Motion Blur* filter is a fantastic means of adding movement to an image. Combining this filter with layers can produce realistic results that can transfrom a dull image into something thrilling.

5 Once you have a realistic-looking blur, select the top layer and turn the visibility back on. Select the *Lasso* tool and set the *Feather* to 25. Make a selection of anything you do not want blurred. The feather will keep a soft transition between the blurred and the nonblurred areas. Once the selection is done, choose everything outside it by selecting *Select > Inverse*. Now hit the Delete key.

6 At this point the back portion of the blurred image below should show through. If you want to remove a portion of the blurred figure, use the *Eraser* tool with a soft brush setting and paint onto the blurred layer. The image should look pretty realistic at this point. Once when you have tried this a few times you will develop a knack for creating a realistic imitation of a motion blur.

RECAP

A Select
Create a rough selection around the object to be motion blurred.

B Blur
Turn off the *Background* layer and apply the *Motion Blur* on a duplicate layer.

C Turn on visibility
Turn the top layer's visiblity back on when you are satisfied with your blur effect.

D Fine-tune
Use the *Eraser* tool to fine-tune any part of the *Motion Blur* that you are unhappy with.

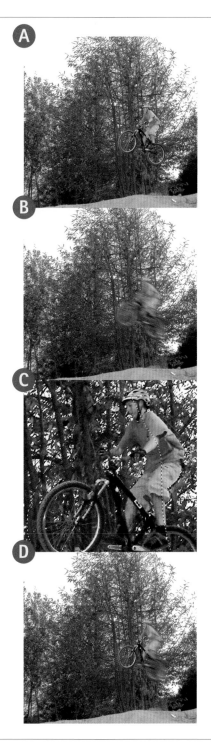

Adding depth of field

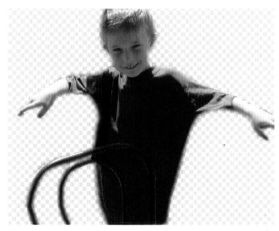

2 Using the selection method of your choice (see pages 46–49), select the boy and the chair in the foreground. The best tool for this job is the *Selection Brush*. Set the brush to a minimum soft edge for the boy and a harder edge for the chair parts that do not actually touch the boy. When this is done, go to the *Layer* menu and select *New > Layer via Copy*. This will lift a copy of whatever you have selected to a layer all by itself, surrounded by transparent areas. This will allow us to work on the background image and leave the boy untouched.

With most (non-SLR) digital cameras, achieving accurate depth of field is often a case of trial and error. Fortunately, no matter what manipulation program you use there are options that enable you to simulate this effect or enhance what little depth of field there might be. This usually demands the creation of a mask, but it can be as simple as adding a little blur to the background and adding tone, density, or contrast to the subject in the foreground. On occasion, reducing the density and sharpening the foreground subject will also be necessary.

1 In this image the boy is the main focus of the shot, but the background contains all sorts of objects that distract the eye: the blue umbrellas are particularly noticeable. To replicate depth of field, we need to isolate the boy from the background and make the background appear out of focus.

TIP Don't worry about creating accurate selections when faking depth of field. A rough selection will usually suffice.

3 Next, soften the *Background* layer. If you wish to retain a copy of the original make sure that you have the *Background* layer selected, and duplicate it by going to *Layer > Duplicate Layer*. There should now be three layers in your *Layers* palette: a *Background* layer, a *Background copy* layer, and *Layer 1*.

Depth of field is exploited to dramatic effect by professional photographers. If, however, your digital camera does not allow you to create depth of field, it's easy to simulate in any image-editing software package.

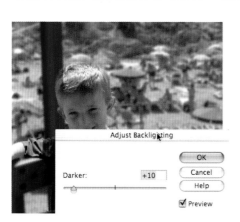

4 Click on the *Background copy* layer to select it, and under the *Filter* menu select *Blur > Gaussian Blur*. For this image a value of 5 should work well, but use what you feel looks appropriate. The background could also do with some darkening. Use the *Backlight* option under *Enhance > Adjust Lighting*. Anything between 10 and 15 will look okay. As this is a daytime shot you should avoid going too dark.

5 Now we need to visually lift the boy. Click on *Layer 1* to select the boy, then create a new *Brightness/Contrast* adjustment layer (*Layer > New Adjustment Layer > Brightness/Contrast*). A dialog box will appear giving you the option to name the adjustment layer, change the layer's opacity or blend mode, and the choice of whether to group it with the previous layer or not. Click on the *Group With Previous Layer* option. What this will do is limit the correction to the layer that is immediately beneath it—in this case the boy. This option is indicated by an upturned arrow beside the adjustment layer's name, and by an underline on the layer below its name after you hit *OK*.

6 When you hit the *OK* button the *Brightness/Contrast* dialog box will appear on the screen. This dialog box is the same one used in the nonadjustment layer correction. The values don't need to be huge. A 10 in each box gives the boy rich color and also lifts him away from the background without looking pasted in.

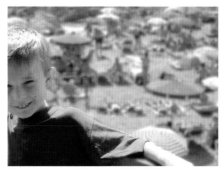

7 At this point it is a good idea to compare a before-and-after image of your changes. If you hold down the Option key and click on the eyeball next to the *Background* layer it will turn off the visibility of all the other layers. When you Option-click it again they will all be turned back on. When you do this check to see if the background blur is too severe or if the correction to the boy is overdone.

THE QUICK FIX

On this image we followed the same basic routine, but without making an accurate mask.

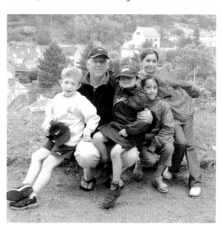

1 This group shot can be improved by softening the background. Creating an accurate mask around the subjects, however, would be a time-comsuming exercise.

2 Instead, a circular oval mask was made around the middle of the group and softened with a 30-pixel feather. The *Gaussian Blur* was set at 2 instead of 5. Then on a *Brightness/Contrast* adjustment layer a 5 was used in the *Brightness* setting instead of a 10. This soft mask was a quick way to avoid the time needed to mask the people out, and as long as you don't go overboard with the blur or the color adjustment, nobody will ever know the difference.

Correcting perspective

1 In this image of a Greek fresco you can see that the sides are bowing out and that the top seems to be leaning backward. We have a good straight line on the left side of the picture but the right side has had the bottom cropped off when the picture was taken. We can use the left side as a guide to straighten the image. It also helps if we turn the grid option on (*View > Grid*) to give us an absolutely straight reference to go by.

H ave you ever had the annoying problem of shots being out of perspective? Buildings leaning backward, and their sides going outward or in at an angle? Or maybe you took a shot of something that was lying flat on the floor, but you couldn't get right over it? Programs such as Photoshop Elements and Photoshop can fix these perspective problems. In Elements you can use the *Transform* tool, while Photoshop gives you an additional option of fixing perspective with the *Crop* tool.

2 Before you do any fixing you need to duplicate your background to a new layer—the *Transform* tool doesn't work on the background image. Select your layer copy, then select *Image > Transform > Perspective*. A bounding box will appear with eight control handles that you can use to adjust the image. Sometimes the box and the handles can be hard to grab, particularly when they're lying against the sides of the image. If this is the case, just hold down the Option-Command-Minus key to shrink the image within its window.

TIP Hitting the Escape key when using the *Transform* or *Crop* tool automatically cancels any changes you have made.

The tremendous flexibility of digital photography allows you to repair even the most stubborn images. Using the *Transform* tool you can correct and adjust the perspective of any image.

PALM PILOT

In this image of a house with palm trees in the foreground you cannot easily see that the perspective is off—trees can grow at an angle sometimes. A close look at the house, however, tells us it pitches inward. For this reason, the same fix can be applied here. However, you will need to concentrate on the house instead of the trees. When the left-hand tree is straightened the house still looks slightly distorted on the right-hand side. If we go any further the left side becomes unbalanced. This is as far as you can proceed with this shot without getting involved with selections or masking. This perspective fix works the same way if the image is bloated outward. Just move the handle inward to pinch the image.

Before

3 Since we are mostly concerned with pulling the top of the image outward, we'll just worry about the top corners for now. Click and hold one of the corner handles and start pulling out to the side. The other corner will move the opposite way to mirror your correction. When you see that the left side is lined up with the grid, turn the grid off. It can sometimes be hard to see things clearly with all those lines in the way. Alternatively, you can change the view back to *Fit In Window*.

4 If the adjustment has worked, you can either double click within the bounding box or hit the Return key. To cancel out of the *Transform* just change tools in the *Toolbox*. You can double check the move by turning *Layer Visibility* off to compare it with the original background image.

After

Adding noise

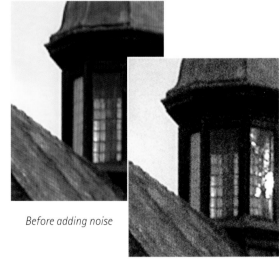

Before adding noise

After adding noise

I t's ironic that, after years of attempting to remove grain from a photographic image, photographers now spend time and effort trying to put it back in. Adding noise to a photo can give it a less electronic feel. It can also fix other flaws, hiding artifacts where a photo has been retouched, for example, or disguising the joins in a composite shot. Like most imaging programs, Elements and Photoshop make the job easy with a dedicated *Noise* filter that applies two types of noise to the image. The first type is *Uniform*, which adds the same amount of noise to every part of the image. The alternative is *Gaussian* noise, which adds more noise to the shadow end of the area to which it's being applied.

 Open up your image and duplicate the *Background* layer by dragging it onto the paper icon at the bottom of the *Layers* palette.

TIP Noise is an effect that you can only get a feel for through practice. Experiment with this filter and observe the results.

 Now launch the *Noise* filter by selecting *Filter > Noise > Add Noise*. Select *Monochromatic* and *Gaussian* in the options, then shift the *Amount* slider to 10%. You'll see the effects in the *Preview* window.

Add Noise

OK
Cancel
☑ Preview

100%

Amount: 10 %

Distribution
○ Uniform
◉ Gaussian

☑ Monochromatic

Noise was once the bane of the traditional photographer but nowadays it is a valuable artistic tool. With the *Noise* filter you can make a digital image appear more naturalistic—but use this powerful filter expediently.

3 The noise gives the shot a "broken up" feel, but if you zoom in to 100% you can see that the noise has almost taken over the image. Unless it's being used as a tough, graphic effect, noise should be almost unnoticeable. The problem with the *Noise* filter is that at smaller amounts, it's hard to discern any changes.

4 Let's take a different tack. Select *Image > Duplicate Image* to

New Layer		
Name: Layer 1		OK
☐ Group With Previous Layer		Cancel
Mode: Soft Light	Opacity: 100 %	
☑ Fill with Soft-Light-neutral color (50% gray)		

make an exact copy of the image. Hit *OK.* Throw away the layer with the noise on it and make a new layer by holding down the Option key and clicking on the paper icon at the bottom of the *Layers* palette. The dialog box that appears allows you to change some of the layers attributes in advance. Set the blend mode to *Soft Light*, and click on the *Fill with Soft-Light-neutral color (50% gray)* box

5 In the *Add Noise* filter use the same settings as you did for the previous image. Use 10% for the *Amount* and turn on *Monochromatic* and *Gaussian.* Then click *OK.* Even though you used the same settings for the noise, the effect on the image is different. With the normal noise application the image was overtaken by the effect. The image with the *Soft Light* layer, however, has a far more subtle look about it.

GRAIN FILTER DIALOG BOX

There is an alternative to using the *Noise* filter: the *Grain* filter (*Filter > Texture > Grain*). This filter allows you to apply different built-in textures to your image in order to mimic film grain. The example shown here uses one of the presets built into the filter. To reproduce the effect, open your image and add a new gray layer with the blend mode set to *Soft Light* as in the previous step 4.

Next, launch the *Grain* filter by selecting *Filter > Texture > Texturizer.* Select *Soft* for the *Grain Type*, 100 for the *Intensity*, and 65 for the *Contrast.* Click *OK* and then desaturate the color by holding down the Command-Shift-U keys. With some grain types you need to do this in order to have monochromatic grain, although this isn't the case with all of them.

Adding texture

One of the things that makes paintings and drawings special is that the textures from the canvas or paper used add a certain depth and quality to the image. There are creative ways of replicating this with traditional photography, but these come at the cost of image quality. As usual, replicating the effect digitally is not only more effective but also a lot less time-consuming. Photoshop Elements and Photoshop allow you to add texture to an image via a filter known as the *Texturizer*. This includes a number of preset textures—you can change the way these work by adjusting the lighting, the scaling, and the relief of the texture or by inverting the texture.

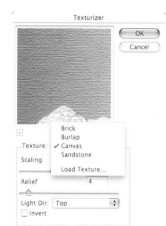

1 Open up your chosen image and duplicate the *Background* layer. Then launch the *Texturizer* filter by selecting *Filter > Texture > Texturizer*.

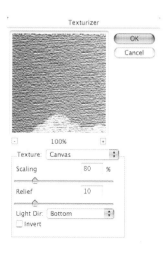

2 In this example *Canvas* is the selected *Texture*, 80% for the *Scaling*, and 10% for the *Relief*. For the direction of the light (*Light Dir.*), choose *Bottom*. After hitting *OK*, zoom into the picture to one of the following percentages: 25, 50, or 100%. The reason for this is that they will show the pattern without any kind of screen moiré (the strange banding effect that appears when patterns interfere with each other).

Elements and Photoshop both allow you to add realistic textures to your digital images. In this way, you can simulate naturalistic painting effects, making it appear as if your pictures are painted on real canvas.

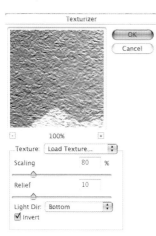

3 As you can see, there is kind of a repetitive pattern displayed. The textures that are supplied with the filter are relatively small, just 256 x 256 pixels, and with a texture-like canvas there is a strong chance of repetition happening. Canvas can be too predictable to fool the eye, so we'll try the filter with a more random pattern.

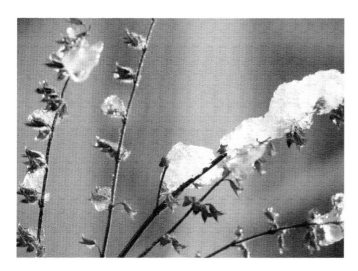

4 Throw out the texturized layer and duplicate a new copy of the *Background* layer. Launch the *Texturizer* filter again. This time, instead of using one of the preset textures, use one of those supplied by Adobe. Click on the pulldown for the texture and select *Load Texture*. Go to the Elements application folder. Open up the Presets folder and then the Texture folder. Select the rust flakes.psd file. Use the same settings as you did for *Canvas*.

5 View the image at 25, 50, or 100%. With a pattern like rust flakes there is much less of a repeating pattern problem, and the texture itself is a lot more appealing than *Canvas*.

MAKING TEXTURES

It is easy to create your own textures. You also have the benefit of knowing what your texture size will be. To make a texture the same size as your image, choose *Select > All*, then *Edit > Copy*. Make a new document. Elements will automatically size your new canvas to the same dimensions of the image in the clipboard. You can now create your pattern or take a picture of something and use that as your texture.

One of the best ways of creating a texture is to use *Noise*. Create a new grayscale image of the appropriate size, then launch *Add Noise* (*Filter > Noise > Add Noise*). Type in 100% for the amount, *Uniform* for type, and click on *Monochromatic*. Now launch *Gaussian Blur* by selecting *Filter > Blur > Gaussian Blur*, and in *Radius* enter 2 pixels.

Launch *Reticulation* by selecting *Filter > Sketch > Reticulation*. Enter 12 for *Density*, 40 for *Foreground Level*, and 5 for *Background Level*. Press OK for the pattern above. Once you are happy, save the file on your computer. You can now open it using the *Load Texture* option from the *Texturizer* in your original, knowing the size will match perfectly.

Advanced color control

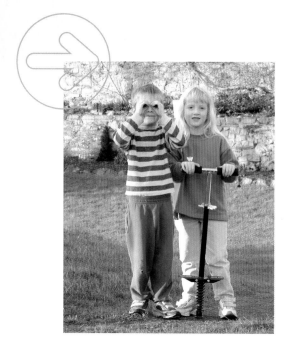

We've already seen how to adjust the overall color of an image using *Quick Fixes* such as Elements' *Color Cast* tool, but there are times when we need to make more precise adjustments. When a particular color is oversaturated, there is only so much that we can do with the tools we've met. We may need to reach for the *Hue/Saturation* control instead, which gives precise control of the color makeup of an image or a selection. It works well for correcting general color problems, but it comes into its own if you want to adjust one of the individual color channels. The eyedroppers in the *Hue/Saturation* dialog become active, allowing you to select any range of colors, narrow or wide, to adjust.

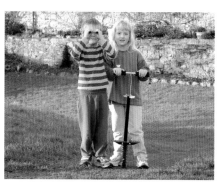

1 Open up the image, and create a new *Hue/Saturation* adjustment layer by going to *Layer > New Adjustment Layer > Hue/Saturation*. Remember, working on an adjustment layer always gives you more flexibility than making an adjustment to the layer itself.

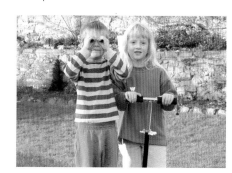

2 The first thing we're going to do is change the bright blue stripes to yellow. Change the *Edit* menu to read *Cyan* and slide the *Hue* slider over to the left till it reads *-125*, which in this case will create yellow. As you can see, changing the *Hue* changed more than just the bright blue stripes. The darker blue and the white pants were also affected.

3 Move the slider back to *0* and click on one of the bright blue stripes. The first thing you will notice is that there are now some brackets on the gradients at the bottom of the dialog box. There are also some numbers that correspond to the brackets and their placement within the gradients. To move the brackets so that they are centered within the gradients hold down the Command key and move the curser over the gradient until a hand appears.

4 When the hand appears, click on the brackets and slide them until they are centered. Now that the cyan color is visible you can see that it shows you the range of the color that you clicked on. This range is adjustable using either the eyedroppers or manually by moving the bars or triangles. If you click in between a bar and a triangle you can move the whole section as it is. You can also move the brackets. The bars represent the selected colors, from the color bar above. The selection is "feathered," so it is at full strength between the brackets and fades to each triangle. You can use the + or - eyedroppers to add/subtract from the selected color range.

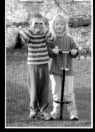

It might seem like a flight of fancy, but the *Hue/Saturation* control allows you to select and alter a range of colors in your image. Just think of the fashion disasters you'll be able to undo.

5 Since you know that just moving the *Hue* slider will affect both pairs of pants, click on the dark blue bottoms with the minus eyedropper. The slider on the right (the area into which that color falls) should move to the left. Alternatively just click on the right triangle and slide it over so that it is against the bar next to it.

6 Now move the *Hue* slider until it reads −125. The stripes are now isolated and have been changed to yellow. You can see the results represented in the lower color bar. Having this isolation option available allows corrections to be made more easily, and it saves you from selecting a specific area every time. You can also change several colors at once. In this case, you could have altered the colors of the red shirt and the grass within the same *Hue/Saturation* adjustment layer, but it often makes more sense not to.

THE HUE/SATURATION DIALOG

When you first open the *Hue/Saturation* dialog box you are presented with controls for the *Hue*, *Saturation*, and *Lightness* for the *Master* channel, plus a visual reference for your adjustments at the bottom in the form of two gradients. The top gradient is a stationary one that represents what the color already is, while the bottom gradient slides to the left or right depending on the way you move the *Hue*, *Saturation*, or *Lightness* sliders. There are also three eyedropper icons that represent selecting a color, adding a color, and subtracting a color. These eyedroppers are grayed out and unavailable to you in the *Master* control. The last option on the dialog box is the *Colorize* button, used to *Colorize* areas of the image with the currently selected color. This option comes in particularly useful if you're tinting monochrome images.

RECAP

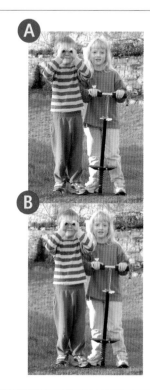

A Pick a color... Using the *Hue/Saturation* dialog you can easily select a range of colors in your image or selection.

B ...any color It is then a simple matter to adjust the color using the familiar *Hue*, *Saturation*, and *Lightness* controls.

Advanced color control

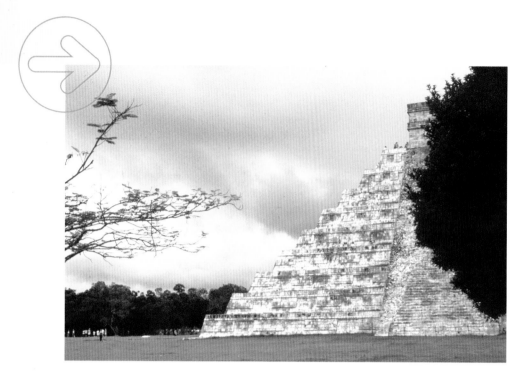

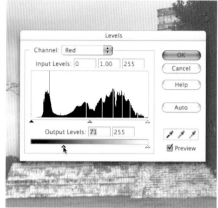

2 Now slide the *Output* slider (at the bottom of the dialog) to the right. Notice that the image becomes progressively redder starting from the shadows.

Color control isn't always about making dramatic changes. For example, the color in this shot of a ziggurat is probably quite faithful, but it does look cold. The shot is too dark, and the tones are on the blue side, probably because it was taken at dusk. In this example we'll use *Levels* to control the colors, as this feature allows us to do more than just add contrast, or lighten or darken an image. It allows very specific control of both the composite image and the individual color channels. Although Elements doesn't let you view the red, blue, or green channel separately, you can still make adjustments to the individual channels and see the results on the image as a whole.

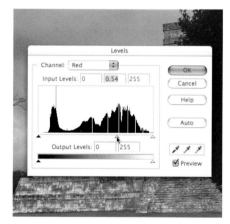

1 Open the image and create a new *Levels* adjustment layer (*Layer > New Adjustment Layer > Levels*. Select the *Red* channel at the top and adjust the *Midtone* input slider (the middle of the three sliders). Sliding the *Midtone* slider to the right adds blue and takes out some of the red.

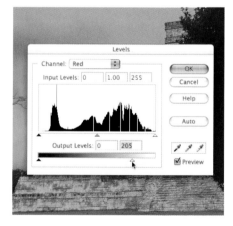

3 Sliding the *Output* slider to the left, on the other hand, makes the image tend toward cyan, starting from the highlights. This is simply a matter of opposites. When you increase or decrease red, its opposite color, cyan, will appear to change. Cyan is red's opposite as it is a combination of blue and green, the other color used to make up an RGB image. The other opposites are blue /yellow and green/magenta.

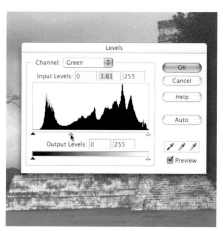

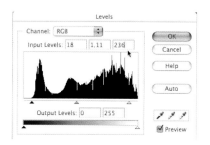

Individual channel correction can make a big difference in how you color correct an image, once you understand what is happening. When you need precision, *Levels* provides the finest control.

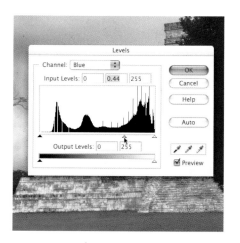

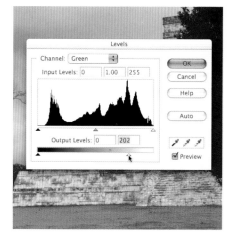

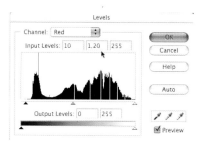

6 Cancel any changes, and return to the *RGB* master channel. Move the *Input* sliders around to adjust the overall tone of the image before making any particular color corrections. Starting at the top with the *Input Levels* enter 18 into the *Shadow* input, 1.11 into the *Midtone* input, and 236 into the *Highlight* input.

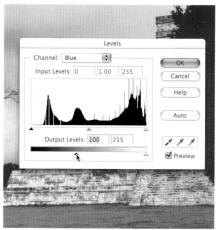

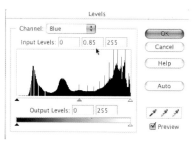

4 The *Blue* channel works the same way, but with yellow as the opposite color. Moving the *Midtone* input slider to the left will add blue or take away yellow, and vice versa if you move it to the right. Sliding the *Output* slider to the right will make the image progressively bluer starting from the shadows. Sliding the *Output* slider to the left will make the image progressively yellower starting from the highlight.

5 Selecting Green and sliding the green *Midtone* input slider to the left will add green or take away magenta. Sliding it to the right will add magenta or take away green. Sliding the *Output* slider to the left makes the image greener, starting with the shadows. Sliding the *Output* to the right makes the image tend toward magenta, starting with the highlights.

7 Now go to the *Red* channel and enter 10 in the *Shadow* input, and 1.20 in the *Midtone* input and leave the highlights at 255. Leave the Green channel alone and go to the *Blue* channel. Enter 0.85 in the *Midtone* input and leave the other values at 0 and 255. The image now has a feel of daylight to it.

TIP If the opposite colors seem confusing, look at the pattern in the *Hue/Saturation* dialog and imagine it as a circle, or "color wheel."

Restoring faded photos

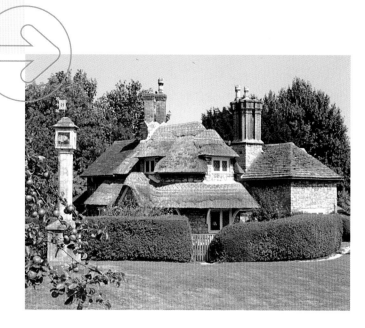

I t is not without its irony that the best-loved photographs are the ones that fade most because they are the ones that see most light. But just because your photos have been on the wall for years doesn't mean they're lost forever. Photoshop can help us bring these images back to life, using not only the *Levels* tool, but the *Color Variations* tool as well. This tool is ideal for determining the problem with a faded image, thanks to its more visual approach. Determining the best tool for the job is often a matter of personal preference, and this process is no exception. In this workthrough we'll see the speed and simplicity of the *Color Variations* tool head to head with the control offered by *Levels*.

1 Duplicate your original layer, then pick *Enhance > Adjust Color > Color Variations*. This brings up a large dialog with before and after images and an array of options. While not as precise a tool as *Levels* for color correction, *Color Variations* is useful in the early stages of a job. It's easy to use, and provides instant feedback through the *Before* and *After* windows.

2 Work through the image systematically, concentrating on the Midtones, Shadows, and Highlights in turn. Lower the *Adjust Color Intensity* value using the *Amount* slider, and click on the increase/decrease thumbnails to get a better color balance.

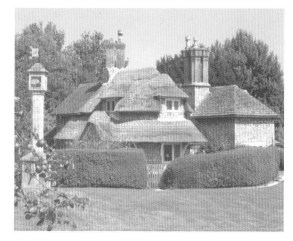

3 Don't make excessive changes at this stage; simply aim to bring the lost colors back and repair as much of the fading as possible. The reds and greens seem to have suffered, so we can enhance them, but pay particular attention to the *Saturation* to give the colors a boost.

All photos, new and old, tend to fade over time. Photoshop presents us with an array of different tools to undo this damage and make things look as good, or better, than they did before.

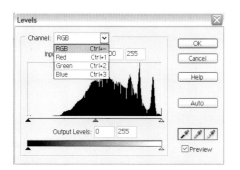

4 Once you're happy with the color balance turn to the *Levels* dialog to correct things more subtly, using the individual channels. At this stage it is more important to be concerned with the balance between channels than the overall contrast.

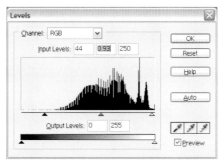

6 With the individual colors interacting nicely, switch to the combined RGB channel to get the overall contrast right. Locating the foothills of the now spikey mountain produces an effective result.

7 Finally, we can go one step beyond color correction by using *Filters > Sharpen > Unsharp Mask* to cure any fuzziness in the image and tighten up the edge contrast. The result is better than new.

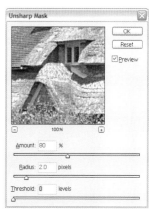

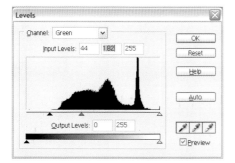

5 The *Green* channel is especially important in this example. The image has a distinct magenta color cast. Using the *Midtone* slider in the *Green* channel gives you a lot more control than if you were using the *Color Variations* dialog. Sliding it to the left weakens the magenta cast and strengthens the midtones. This really brings out the green of the hedge and grass.

TIP Don't worry about very close spikes on the RGB *Levels* chart. This happens as a result of the work already done.

RECAP

Ⓐ Balance
The easy-to-use *Color Variations* tool can quickly sort out any major balance problems.

Ⓑ Tone
The individual channels on the *Levels* dialog can be used to fine-tune the coloration.

Ⓒ Contrast
Finally, the combined channel on the *Levels* dialog sorts out contrast beautifully.

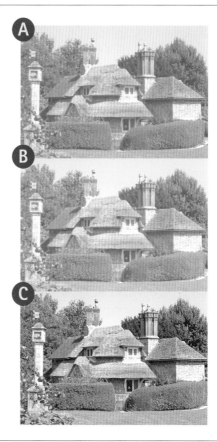

Fixing hard shadows

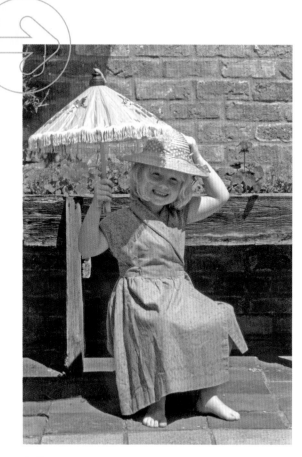

Taking photographs in bright sunlight often creates problems because of the extremes in contrast between highlights and shadows. If you position your subject so that as little of their face is in shadow as possible, they end up squinting into the sun. People you want to photograph will often naturally turn away from the sun, plunging their features into shadow. An alternative fix may be for them to use a parasol to shade them from the sun, but this also creates a problem—if you get the highlight exposure right, you lose detail in the shadows, and vice versa. The latest version of Photoshop, Photoshop 8, offers a powerful feature for fixing this problem—the *Shadow/ Highlight* adjustment dialog.

2 Select *Image > Adjustments > Shadow/ Highlight*. This opens a dialog in which you can manipulate the shadow and highlight areas of your image.

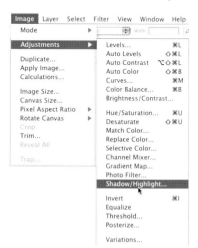

1 In this original, the subject's face is all but hidden in shadow. Using a combination of image adjustments applied to selected areas, it's possible— although time-consuming—to fix this problem, but there's a quicker way if you have the latest version of Photoshop.

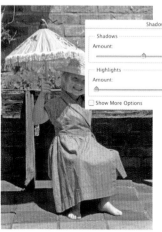

3 The default settings in the *Shadow/Highlight* dialog apply a 50% value to the shadows in the picture, but nothing to the highlights. In our photo, we need to apply some tweaks to the shadow areas as they are still just a little too dark.

4 To lighten the shadows, we've moved the *Amount* slider to the right, increasing the "light" (not too much or the photo will become dull and flat). The result is just a little colorless. Fortunately, the *Shadow/Highlight* dialog has further, more powerful controls. To show these, check the *Show More Options* box.

Important detail in a photo is often lost in shadows when shot in bright sunlight. Photoshop offers a clever feature for balancing the contrast between shadows and highlights, restoring detail that would otherwise be lost.

<div style="text-align: right">*Fixing hard shadows*</div>

5 To adjust the color, move the *Color Correction* slider in the *Adjustments* panel a little to the right (the default is +20, so we've increased the amount to +40). This increases the color a little.

TIP In extreme cases, try running the *Shadow/Highlight* adjustment twice—but reduce the shadow amount the second time.

RECAP

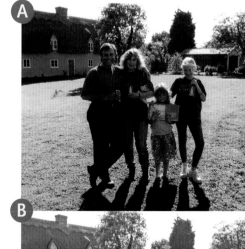

A Pictures shot with the sun behind the subject will invariably ruin a shot.

B But, secure in the knowledge that you can fix any problems in Photoshop with its *Shadow /Highlight* feature, you can now use the shadows to add a little compositional drama—without losing any of the shadow detail.

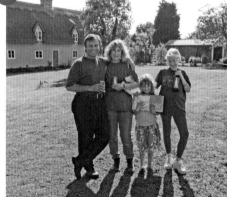

6 The end result is still a little cool overall. Photoshop—again, later versions—offers an adjustment feature called *Photo Filter*, which mimics the effect that photographic gel filters have on a photograph when placed in front of the camera lens. Select *Image > Adjustments > Photo Filter*. In the *Use* panel, click on the *Filter* button. Although the *Color* option allows you to define your own color, the pop-up menu in the *Filter* option shows a list of presets. We chose *Red*. Used at full strength this filter will flood the image with color, so the *Density* slider offers control over the strength of the filter. We set this to 30%.

Enhancing skies

Sometimes as a photographer, you'll take a shot in which everything— luck, timing, talent, and technology— all seem to come together at once. These are the shots that leave everybody saying, "wow!" Sadly, there are other shots where just one thing goes wrong, and you miss that big chance to take a brilliant picture. Few subjects are as tricky in this respect as skies, sunsets, and sunrises. Look at the sky in this sunset shot—it could really use some added punch. Instead of a great, vibrant image, we have a reasonable but slightly dull effort. Fortunately, this can be rectified.

1 Create a *Levels* adjustment layer and push the *Midtone* slider to the right to darken the image. Next, pull the *Highlight* slider over until the *Midtone* slider is even with the histogram edge. The result is rich colors and dark darks. The darks are, however, too dark—they steal the show from the other colors. The red colors are also vibrant. It would be nice to be able to adjust all of these features separately.

2 Remember that there are many different blend modes available to you in the *Layers* palette. You also have the option of making no adjustments at all within a dialog box. Try this: make a *Levels* adjustment layer and hit *OK*. There should be no change at all to the image. Now change the blend mode to *Soft Light*. You will see a very similar shot to the straight *Levels* adjustment.

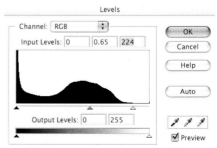

With adjustment layer masking, we can apply corrections to selected parts of an image, with real control over how the change affects each portion. Combine this with the *Gradient* tool and there is no more need for lens filters.

3 Adjustment layers have an advantage over regular layers in that they can be masked. To create a mask, click once on its thumbnail (the white area to the right of the layer icon). A small black outline will appear around the thumbnail, indicating that it is selected. White areas of the mask mean the layer is 100% effective, black areas have no effect.

4 Next, click on the *Gradient* tool in the *Toolbox*. In the *Option Bar* choose the fourth gradient option. Set the transparency to 50%. With your foreground color set to white, click and drag from the top of the image to the bottom so that you have a mask similar to the one opposite. Remember, it will appear in the *Layers* palette thumbnail, not in the main image.

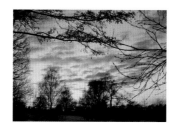

5 As you can see, this has the effect of lightening the top and bottom of the shot while leaving the middle alone. In effect, half of the blend mode adjustment is blocked off. This is preferable to simply adding a mask to a straight *Levels* correction. Here, we achieve the correction without having to blend the colors manually. If we change the blend mode now we will still have the same balance, without having to worry about adjusting the levels more to compensate.

6 Now duplicate the *Levels* adjustment layer by either dragging it to the paper icon at the bottom of the *Layers* palette or by going to the pop-up menu in the top right of the palette and selecting *Duplicate Layer*. Change the blend mode to *Linear Burn* or to *Color Burn*. Then click on the mask icon and invert it by either pressing Command-I or selecting *Image > Adjustments > Invert* from the *Menu Bar*.

7 Reversing the mask adds more color to the sky and blends in the branches more. The shot now has much more impact and contrast than it did previously.

RECAP

A Levels
Use a *Levels* adjustment layer to bring out the weaker areas.

B Soft Light
Use an unedited adjustment layer in *Soft Light* blend mode.

C Gradient
Draw a *Gradient* to apply your effect just to the regions you want.

TIP If you want to draw gradients at exact angles, hold Shift as you draw and it will be drawn to the nearest 45 degrees.

Lighting effects

2 Set your RGB *Input Levels* to 18, 1.11, and 236 left to right. Then set the *Red* channel's *Input Levels* to 10,1.20, and 255 left to right, and your *Blue* channels inputs to read 0, 0.85 and 255. These adjustments give the image a warm, sunny look. However, there are still some blue areas that prevent the adjustment from working fully. The girl's shirt, for example, has a slight blue cast to it in the shadows, and her face could be a touch sunnier.

O ne of the commonest problems of all is a nice image that has simply been taken at the wrong time of day. Such images go from having great potential to being merely average. Look at this picture of a woman in a boat; the photograph fares pretty well in capturing some of the sun that was left before dusk. There is still, however, a slight blue cast to the whites and the grays in the image and even the flesh could use a little enhancement. These flaws can be remedied in most image-editing programs. Using a combination of *Levels* and a *Color* adjustment layer you will be able to improve things considerably.

 1 Open the image and create a *Levels* adjustment layer.

TIP
→ For even greater control of the digital photograph you can mask off the portions of the image that you want to remain unaffected by your adjustments.

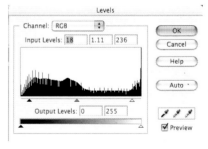

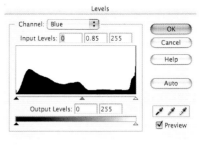

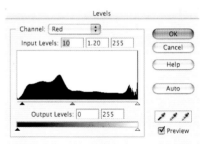

An image can be ruined if the weather conditions are inappropriate. Fortunately, you can exert considerable control over the appearance of the lighting using adjustment layers while tweaking the *Hue* and *Saturation* of the colors.

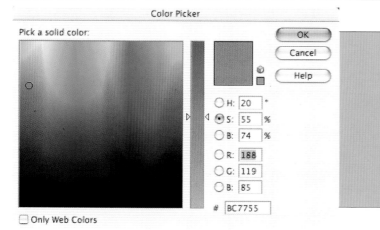

Color Picker

Pick a solid color:

OK
Cancel
Help

H: 20 °
S: 55 %
B: 74 %
R: 188
G: 119
B: 85
BC7755

☐ Only Web Colors

3 To fix this, click on the *Background* layer, and then make a new *Color Fill* layer by selecting *Layer > New Fill Layer > Solid Color*. This will open up the *Color Picker* dialog box. Type 20 in the *Hue* box, 55 in the *Saturation* box, and 74 in the *Brightness* box. Click *OK*.

4 The image has improved, but there are still one or two problems. We need to change the blend mode of the layer to *Overlay* and the *Opacity* down to 18. The *Opacity* of the layer dictates how much of this color will affect the image. If you feel that 18 is too little or too much, adjust it up or down. This overlay layer adds just enough red to the image to take away some of the blue cast and add some contrast to liven things up. To some extent, this technique mimics a daylight filter. With some experimentation with different colors you will be able to successfully mimic other types of filter.

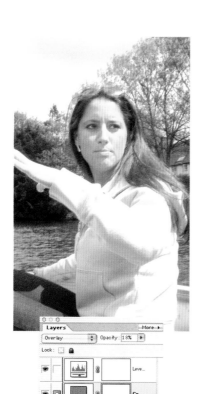

RECAP

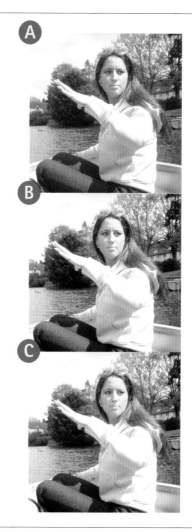

Ⓐ New layer
Create a *Levels* adjustment layer and adjust the *Input Levels* to give the image a sunny appearance.

Ⓑ Adjust brightness
Fine-tune the image by creating a *Color Fill* adjustment layer and adjusting the *Hue* and *Saturation*.

Ⓒ Blend mode
Finish off the effect by changing the blend mode to *Overlay* and reducing the *Opacity* of the layer.

Lighting effects

Cast color Opposite color

Everyone has come across those dreaded fluorescent bulbs at one time or another. Yet many people have not even heard of filters that cancel out the yellowing effect that they produce. Digital camera manufacturers are beginning to add this control to their cameras, but what can you do in the meantime to counteract the problem? This shot has the additional problem of the highlight coming in through the window and shining onto the heads. Using *Levels* or any other color adjustment tool will enable you to improve the coloring but the highlight will become even more pronounced. The best thing to do is get rid of the cast.

1 Using the *Eyedropper* tool, select the gray suit worn by the man on the right. It should read something close to R74, G71, and B18. Now create a new document, making sure that the color space is RGB. If you are working in RGB already (as you probably are in Photoshop Elements), then you can simply use a new layer.

2 Fill the new layer with the selected color by pressing Option-Delete (Alt-Delete) and then invert the color by hitting Command-I (Ctrl-I). Your color should now read close to R178 G185 B239. This creates a color that is the exact opposite of the one selected to cancel out the cast. Next, create a new *Color Fill* layer by selecting *Layer > New Fill Layer > Solid Color*. When the dialog box appears, enter 50 in the *Opacity* and change the blend mode to *Soft Light*.

Inconsistent color casts in digital images are a common problem caused by fluorescent lighting. You can use a combination of *Color Fill* layers and color channel adjustments to quickly and easily eradicate this flaw.

3 The *Color Picker* box will appear with the color you selected already in place, and the image should lose much of its yellow cast. Click *OK*.

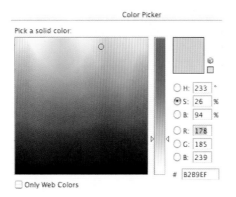

4 Now create a *Levels* adjustment layer by selecting *Layer > New Adjustment Layer > Levels*. With the shadow input selected move the slider to 23. This should bring back the depth you had before creating the color layer.

TIP In addition to correcting problems caused by fluorescent lighting, this method will cure almost all types of color cast.

5 The shot is still a little too yellow. To rectifiy this, change the *Opacity* of the *Color Fill* adjustment layer to 80% and double click on the color icon in the layer. In the *Color Picker* box that appears select the hue box (*H*). Holding down the Shift key, press the up arrow key to move the hue to the right and bring in a little red. Stop when it reaches 245 and then change the saturation (*S*) to 50.

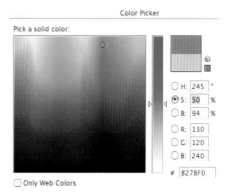

RECAP

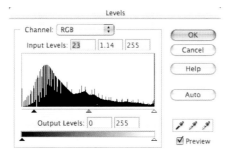

A Select a color
Use the *Eyedropper* tool to select the color of the suit worn by the man on the right.

B Create a new layer
Create a new *Color Fill* adjustment layer that is the opposite of the color selected and change the blend mode to *Soft Light*.

C Bring back the depth
Reduce the remaining yellow cast by creating a new adjustment layer and adjusting the color values in the *Levels* dialog box.

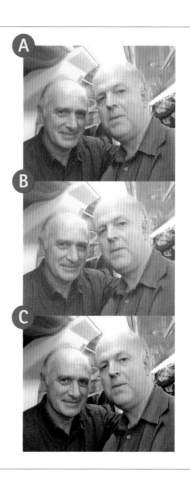

Replacing backgrounds

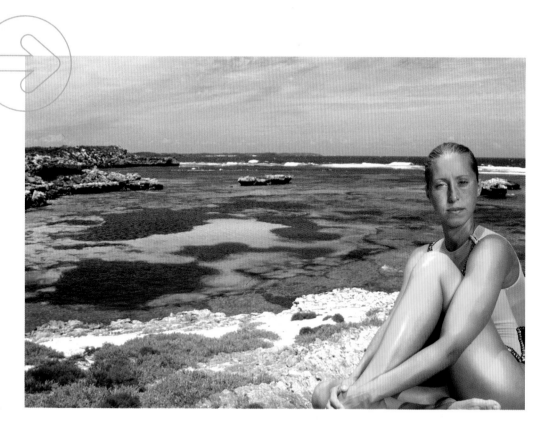

There will always be times when you wish to have the background in a shot either changed or removed. Sometimes it's because something popped into the picture as it was being shot, sometimes it's because the background is too plain. Depending on the complexity of the image to be masked out of the background, Photoshop Elements can handle this admirably. And once you have created a montage of images, it is a simple matter to get the look just right. Later on you can come back and reposition, or even duplicate, any one of your subjects.

1 In this example we're going to marry an image of a swimmer with a rocky coastline. The swimmer will need to be masked out of her background fairly carefully. You can tweak the masking after you get her into the beach image. Once you have made the selection, save it by going to *Select > Save Selection*. There you will be prompted to name the selection. Get used to naming selections. There will be times when you have multiple selections saved and you'll want to identify easily which one is the one you need.

Digital imaging has made it infinitely easier to put people where they have never been, or even onto a background of your own creation. Essentially the process is little more complex than cutting and pasting in a word processor.

2 Now switch to the *Move* tool and drag the swimmer into the beach scene. Hold the Shift key down while you drag so that the girl falls into the center of the image. The figure will seem large, as the resolution of the first image was much higher.

3 To make the image look more authentic, the woman needs to be resized and have her perspective changed. You can do all of the adjustments at the same time by going to *Image > Transform > Free Transform* or by pressing Command-T. This will place a bounding box around the swimmer and also change the *Options Bar* to allow for manual adjustments. If you use the manual adjustment in the *Options Bar* for resizing, make sure you click on the chain in between the two entry boxes. This will ensure that no distortions happen in the width and length of the figure. Type 90% into one of the boxes. When you do this, the other box will update with the same percentage. Now drag from within the bounding box and move the swimmer so that the edge is slightly below the image edge. Next, either double click inside the bounding box to accept the change or click on the check mark on the *Options Bar*. If you wish to start again, click on the circle with the line through it in the *Options Bar*.

Replacing backgrounds

4 Now that the swimmer is sized correctly, you need to ensure the lighting is consistent. First create a *Levels* adjustment layer and move the bottom right *Highlight* slider to the left to flatten out and darken the figure. Then press Command-G to group the adjustment layer to the swimmer's layer. Because it is grouped, anything done to the *Levels* adjustment layer will only affect the layer below it. It is possible to group many layers to a single layer.

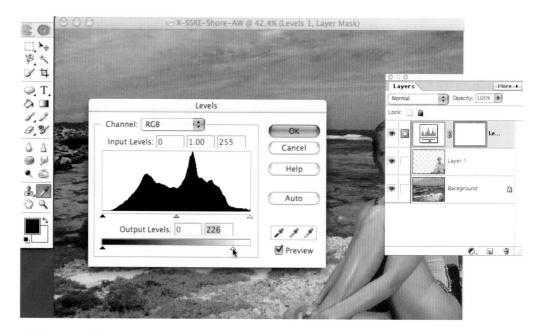

5 Make another *Levels* adjustment layer and move the *Midtone* slider to the right to darken the swimmer. Then fill the mask with 100% black to hide the adjustment and press Command-G to group it with the swimmer.

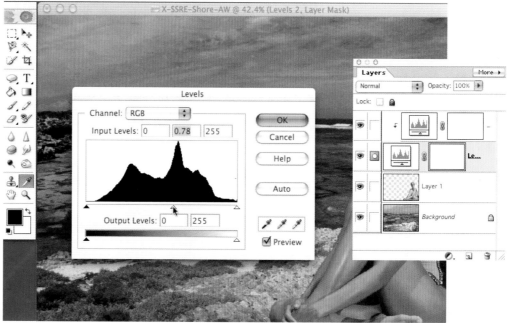

TIP Photoshop users can use the *Extract* tool, and Elements users can choose from some 3rd-party plug-ins to select difficult shapes.

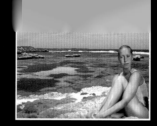

Once you've cut and pasted your image, you can add adjustment layers to any one layer in order to get a convincing final result.

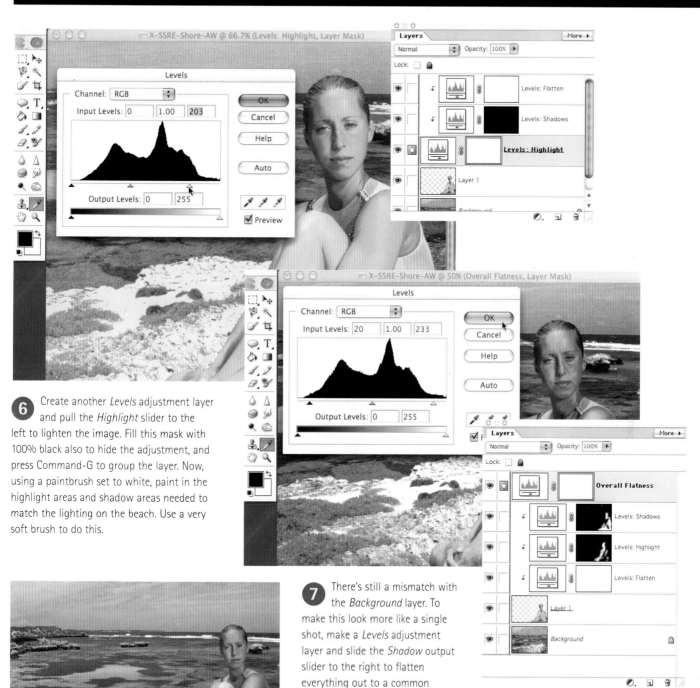

6 Create another *Levels* adjustment layer and pull the *Highlight* slider to the left to lighten the image. Fill this mask with 100% black also to hide the adjustment, and press Command-G to group the layer. Now, using a paintbrush set to white, paint in the highlight areas and shadow areas needed to match the lighting on the beach. Use a very soft brush to do this.

7 There's still a mismatch with the *Background* layer. To make this look more like a single shot, make a *Levels* adjustment layer and slide the *Shadow* output slider to the right to flatten everything out to a common flatness. Slide the *Shadow* input to the right till it reads 20 and slide the *Highlight* input to the left till it reads 233. Finally, lock the adjustment layers to the girl's layer by clicking in the blank square to the left of each layer. If you have to move the swimmer or change her in any way, the corrections will move with her.

Creating backgrounds

Trying to create your own background can be entertaining. It can also complement the image better than some backgrounds that you might find. Looking at the image of the boy with the superhero facepaint, the background doesn't do it any justice. But what could you possibly use to replace the background that would fit the mood of the shot? Creating one would probably be a lot easier.

2 Once the masking/erasing is complete and you've saved it as a selection, go to the *Layers* palette and make a new *Solid Color* adjustment layer. Do this by selecting the *Background* layer then clicking on the circle at the bottom of the layers palette and choosing *Solid Color*. The new layer will appear above the selected one (and hopefully beneath our subject). Now all we need to do is click on one of the reds in his facepaint to select an appropriate color.

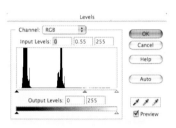

3 Make a new *Levels* adjustment layer above the *Solid Color* one, and set its blend mode to *Vivid Color*. Click on the mask to activate it. Set your foreground/background colors to black and white and go to *Filter > Render > Clouds*. Repeat this a few times until you are happy with what you see. When this is done, double click on the *Levels* icon in the layer and slide the *Midtone* slider to the right till it reads 55. Now Command-click on the mask for the color layer to load its selection. Select *Inverse* from the *Selection* menu or press Shift-Command-I. Once this is done, fill the selection with 100% black by using the *Fill* command from under the *Edit Menu*.

1 Mask out the boy entirely. Don't worry about how smooth it might be around the hair. Use whatever method you like. In Photoshop Elements the easiest method is to duplicate the layer with the boy on, switch off the visibility of the *Background* layer, then erase around the boy. Don't worry if your hands aren't perfectly steady, just keep letting go of the mouse button and using *Undo*—Command-Z (Ctrl-Z)—to correct any mistakes.

A bit of creativity with the many blend modes and adjustment layers can make a quick and striking background for any image. Here the young subject is brought a step closer to the dramatic surroundings of a superhero.

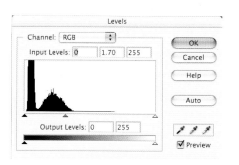
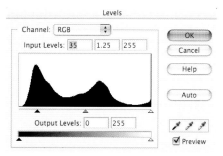

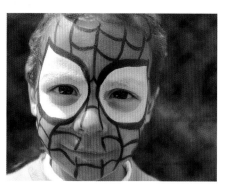

6 Last step. Duplicate the layer from the previous step. Adjust the *Levels* so that the *Shadow* reads 0 and the *Midtone* reads 1.00. Place it beneath the face in the *Layers* palette. Now change the blend mode to *Multiply*. This adds some drama to the image and ties the boy's head into the background.

4 This already makes a dramatic change to the image. Now make another *Levels* adjustment layer, between the face and the cloud layers. Fill the mask with 100% black. Make a selection in the shape of an X across the mask. Make sure it is feathered softly but not too softly (use about a 10). Fill the selection with 100% white. Then double click on the *Levels* icon and adjust the *Midtone* to the left to read 1.70. This opens up the areas in the X and brightens part of the clouds below, giving the background some depth.

5 Make a *Levels* adjustment layer above the face and group it with that layer only. Now select the gradient tool. Set your foreground/background colors so that the foreground is white and the background is black. Select the *Radial Gradient* from the *Options Bar*. Starting from the middle of the nose, draw outward till you reach the side of the face. Then double click on the *Levels* icon and adjust the *Midtone* to 1.25 and the *Shadow* to 35. This will give the face some depth to match the new background.

TIP Making backgrounds doesn't always take this many steps. But then again, once you get used to doing this it will not take all that long, perhaps 5 minutes at the most.

Removing objects

Taking pictures does not guarantee a picture-postcard result. You could wait around forever until people stop walking in front of you, but sometimes it just isn't going to happen. Other objects, such as telephone poles, are even less likely to walk away. Most image-editing packages can get rid of such items. As usual, there are several ways of going about it, and which you use often depends on how complex the scene and the unwanted object are. For instance, this harbor scene is a good shot, but it would be even nicer if the spotlight wasn't in view. In this case moving a piece of the water over to cover it is the best option. Despite its size, the pattern of the copied water should blend in nicely.

1 First, use the *Lasso* tool to make a selection around the light. Make sure that the selection is flush against the wall but loose around the water areas.

2 Now move the selection to the right until it is past the light. Hold down the Shift key as soon as you start dragging the selection to constrain the movement to a straight line. This makes it easier to cover the light later on. Once you have it where you want it, give it a feather of no more than 2 pixels, then copy it to its own layer by going to *Layer > New > Layer via Copy*.

Removing objects in your photographs is no longer a matter of unscrewing things from the wall and waiting for everyone to get out of the way. You can simply patch them out using other areas of the image.

CLONING AND PATCHING

Sometimes there is a lot to be removed from an image and you need to use the *Clone Stamp*, then patch with areas from around the spot needing to be fixed. The shot of the castle would be great if it wasn't for all of the cars and people. This will go a lot faster with the use of layers and adjustment layers to correct the patches so that they match the new areas.

1 We want to get rid of the vehicles. First, select areas of the wall and move them around to cover up where needed. The same goes for the road. Use the *Eraser* tool set to brush mode to clean up the edges, then use the *Clone Stamp*. Remember to keep horizon lines and repetitive areas in mind, and it can be useful to use the different blending modes with the *Clone Stamp*. For instance, where the foliage comes up over the wall, use *Lighten* instead of *Normal*.

2 At times it can also be helpful to have *Use all Layers* clicked on in the *Options Bar*. This samples all the layers and uses whatever is on top as the clone source. If you have moved a lot of patches to their own layers this can help out a lot.

3 Now, using the *Move* tool and holding the Shift key down, drag the new layer over to where the water butts up against the wall. Use your arrow keys for precise placement. Now that you have the water there, you are going to need to adjust the color and density to match the surrounding water. You can do this by using a *Levels* adjustment layer grouped with the water patch. No one will ever know the spotlight was there.

3 Finally, merge all of the patches onto one layer and fine-tune what you have done. This could be fixing the edging or adjusting light sources wherever needed

TIP Remember that doing this gives you creative license. Make the final picture look right, rather than accurate.

Removing objects

CLONING

When you need to erase large areas of an otherwise perfect picture it is often easiest to use a combination of large copied areas and then soften the edges and fill in the gaps with the *Clone Stamp*. In this example use the *Clone Stamp* tool to remove the telephone wires and cover the road with pristine areas of the background, blending and filling with the *Clone Stamp*.

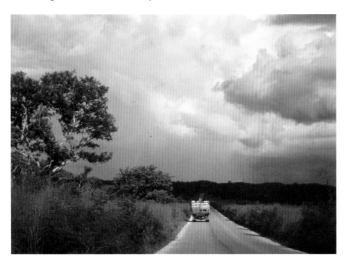

1 There are two key techniques to remember when cloning. First, you hardly ever have to use the tool at a 100% *Opacity*— instead select an *Opacity* of around 40% from the *Options Bar*. Second, remember to change your source point frequently, Option-clicking (Alt-clicking) on a new area of similar hue and texture. These techniques will ensure you avoid the visible repetition that can often spoil cloned images. With these tips in mind, clone over the telephone wires and post, paying particular attention to the areas around the skyline.

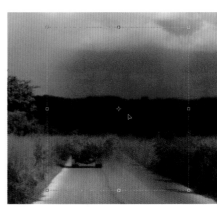

2 Select the *Lasso* tool and, in the *Options Bar*, set *Feather* to around 30 pixels. Now select a large area to the right of the road. Don't worry about the shape you draw, the more irregular the better, as it will help disguise the edges. From the *Layer* menu select *New > Layer via Copy* to create a new layer containing only your selection.

3 Click on the *Move* tool and drag the contents of your new layer until it covers the road, and the skyline roughly lines up. Select the *Eraser* tool with a large soft brush size and an *Opacity* of around 30%. Carefully begin to delete areas of the copied layer to blend it in. Because of the large feather the join won't be too obvious in areas with a lot of detail, but in areas of solid color, such as the sky, the patching will be quite obvious.

The patching and cloning principle from the previous page can work in many different ways. Here any sign of this road has been obliterated thanks to the careful use of the *Clone Stamp* tool.

4 Now repeat this process to build up a layer of foliage over the road. You can speed up the process by Control-clicking your selection on a Mac (Right-clicking in Windows) and choosing *Layer via Copy* from the contextual menu that appears.

5 Finally switch back to the *Clone Stamp* tool. Because you need to recover some of the sharpness in the foliage, use a strong *Opacity* of around 80%. Also, because we have built up a number of layers containing source material, make sure you check the *Use All Layers* box in the *Options Bar*. Now clone over areas that appear overly fuzzy, repetitious, or the wrong color or texture. When you are happy with the result, a final trick is to use *Filter > Noise > Add Noise* across every layer. Adding the same amount of noise to all the layers and elements ties them all together, greatly improving the authenticity of your work. You only need a little, around 2.5% set to *Gaussian Monochromatic*. Make sure you repeat this on every layer.

TIP Don't forget to move selections vertically as well as horizontally to avoid obviously repeated areas, and make good use of the *Eraser* tool to blend and soften joins.

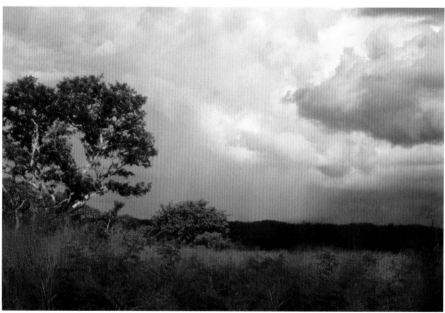

Removing objects

PAINTBRUSH TOOL

A tooth brace takes a long time to do its job. There's no quick fix for removing one digitally either. Retouching a photo to get rid of a brace requires a bit of patience and plenty of care, because the only way to guarantee a good result is to use the *Paintbrush* tool on its own.

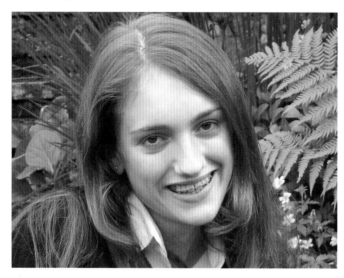

1 Make a copy of the background layer—especially important when you're going to be painting over the original pixels.

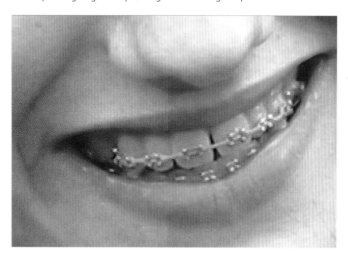

2 Increase the view to 300% so that you can see more clearly what you are doing.

3 Select the *Paintbrush* tool, giving it a size small enough to work with. We used a 5-pixel brush.

4 Position the brush over the tooth near the brace. Now press the Option/Alt key. The *Paintbrush* cursor changes to the *Eyedropper* cursor. Click to select a color.

5 Now carefully start painting over the brace, painting just a little at a time.

6 Repeat step 4, selecting a tooth color near the next bit of brace you're painting over. Repeat step 5, again painting over just a little piece of the brace.

7 Continue repeating the color selection and painting steps, selecting a new color with the *Eyedropper* each time there's a slight change.

Careful use of Photoshop's painting tools can work wonders. In real life it can take months to straighten teeth, digitally we can do it in a few minutes. What better way to show someone that all those trips to the dentist will be worth it in the end?

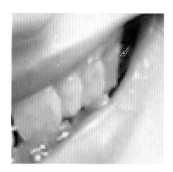

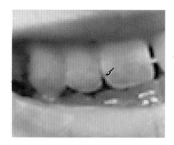

8 Toward the back teeth, things get a little more complicated and you may have to guess a little at where the teeth are because the brace can hide an entire tooth. Be careful to use the shadow color to paint out the brace in the darker recesses.

10 Remember, you're being a cosmetic surgeon here, so you can also correct a few imperfections on the way, such as smoothing out jagged teeth. Reduce the brush size for more detailed areas.

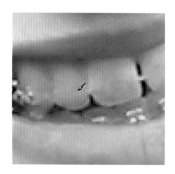

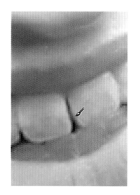

11 Removing the brace has revealed a slightly larger gap in the top two front teeth (the brace hasn't finished its job yet!), so extend the two teeth either side of the gap by carefully adding a little sampled tooth color. Take care not to make the teeth too big!

9 Although a slight variation in color is a good thing, the color may look a little uneven on larger areas of tooth. If it does, reduce the brush *Opacity* to about 50% and paint over the area again. This will have the effect of smoothing out the color but retaining a little color variation.

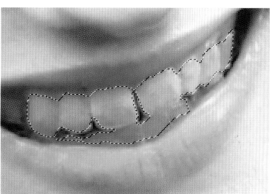

12 Removing the brace using sampled tooth coloring has left the teeth looking a little grey, so, using the *Lasso* tool, make a selection of the teeth (enamel only—you don't want to lighten the gums). Give this selection a feather of about 3 pixels.

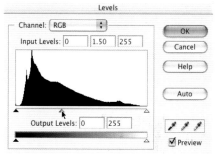

13 Now choose *Enhance > Adjust Brightness/Contrast > Levels*. In the dialog box, move the *Midtones* slider to the left until it reads about 1.50. There's a temptation to make the teeth look very bright and white, but don't overdo this as the result will look too obviously retouched.

TIP It's easier to use the brush if the cursor represents its size. To change the default look of the pointer, go to *Preferences > Displays & Cursors* and select the *Brush Size* option.

Removing scratches and tears

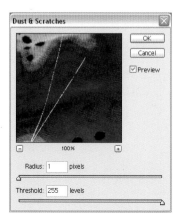

Repairing badly damaged photos is easier than you might imagine. With a bit of judicious cloning from other parts of an image, you can achieve results that won't be noticeable to anyone but yourself. All you need to do is overcome that nagging desire for perfection. The aim here is not to recreate the information perfectly because neither you nor your audience can know exactly what that was. Replacing an empty area with something that looks convincing is just as good and, at the very least, looks better than a great big tear or fold.

1 First of all, crop the scanned image to remove the worst of the damage. Next, zoom in on the scratches. To remove these, first highlight an area around them using the *Selection Brush* tool.

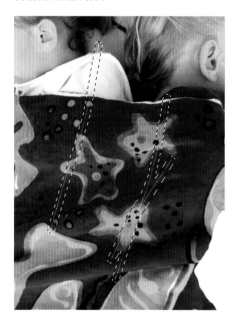

2 From the menu, choose *Filter > Noise > Dust & Scratches*. In the dialog, check the *Preview* box to see changes in the image window as you make them. Move the *Radius* slider all the way to the left so that it gives a value of 1. Drag the *Threshold* slider all the way to the right so that it gives a value of 255.

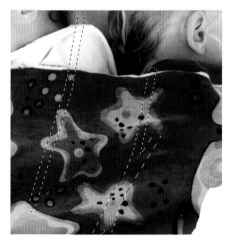

3 Now move the *Threshold* slider gradually to the left until the scratches disappear. If the slider can't move any farther to the left and the scratches are still visible, move the *Radius* slider slightly to the right so that it gives a value of 2. Now repeat the process of moving the *Threshold* slider all the way to the right and then gradually to the left. For this photo, we gave the *Radius* slider a value of 3, and the scratches disappeared when the *Threshold* slider reached 21.

On first inspection tears can seem to destroy an image, but nine times out of ten things can be repaired with a little bit of lateral thinking.

4 Now to repair the tear in the photo. The pattern on the duvet is quite well defined, but there's no need to try and paint in the fabric to match the pattern; we'll just copy another part of the design. Begin by drawing a rectangular *Marquee* around the tear.

5 Now move the selection to another part of the pattern. Make sure you still have the *Marquee* tool selected when you do this or you'll move the underlying image rather than just the selection *Marque*).

6 Choose *Select* > *Feather* and give the selection a feather radius of about 16 pixels.

7 Now turn this selection into a new layer by choosing *Layer* > *New* > *Layer via Copy*.

8 Using the *Move* tool, position the new layer somewhere over the torn patch.

9 The new patch doesn't fit too well so we'll make some adjustments: choose *Image > Rotate > Flip Layer Horizontal*. Now choose *Image > Rotate > Free Rotate Layer* and rotate and reposition the layer until it lines up with a strong feature on the image, in this case a fold in the duvet. When you're happy with the position, click on the *Commit Transform* checkmark in the status bar (or hit the Return key). When done, flatten the image and save it (keep a layered copy if you think you'll want to make more changes). Because of the random nature of the fabric design, and the feathering of the repair, it will not be noticeable to anyone but you.

RECAP

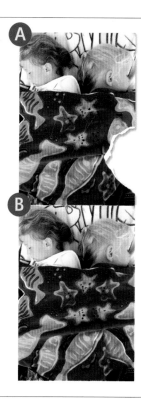

Ⓐ Rip off
Look at the damage and plan your actions. Here we need to borrow a bit of duvet.

Ⓑ Blend in
Once you've got your patch in place, rotate it and feather the edges to ensure a good fit.

Compositing multiple shots

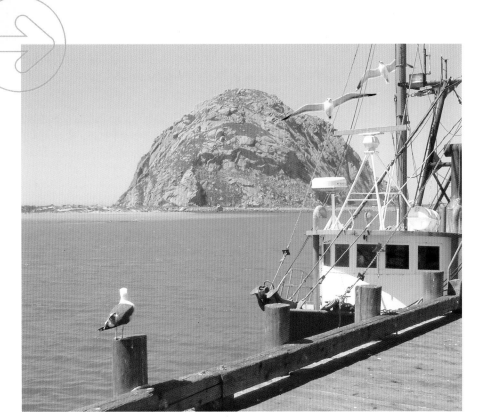

Photoshop's compositing abilities are well known, but most people tend to associate this kind of work with obvious montage-style productions, changing the background of images, and so on. Sometimes, however, the best composite shots are the ones where the viewer has no idea the image was made from two or more original parts. Be very choosy when you pick the elements to use in a composite image. If the lighting is noticeably different in each shot then the result will not be convincing—and adjustments can only do so much. Here, we're adding some gulls in flight to a harbor view.

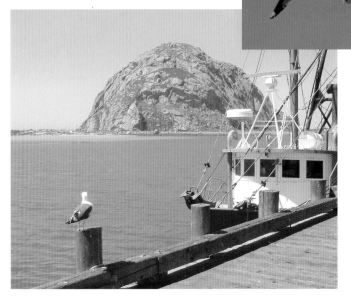

1 First, duplicate the *Background* layer in the first gull photo. Open the *Layers* palette to see what you're doing, then choose *Duplicate Layer* from the *Layers* menu (or drag the layer to the palette's *New Layer* icon) and you'll see a new layer appear. Click the visibility icon (the eye symbol) to hide the original background layer.

Compositing can be used not only to move people into new images, but to enhance any picture with some new points of interest. Adding the seagulls really gives this trawler atmosphere, implying a fresh catch is onboard.

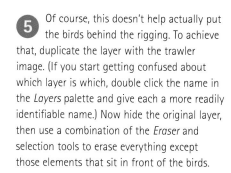

2 Now cut away the sky in the image. This can be done with the *Eraser* or by making selections and deleting them—whichever combination of tools and techniques feels the most comfortable. You could do all the trimming here, but it's better to scale first. Just trim the excess sky, then use the *Move* tool to drag this layer into the trawler photo.

5 Of course, this doesn't help actually put the birds behind the rigging. To achieve that, duplicate the layer with the trawler image. (If you start getting confused about which layer is which, double click the name in the *Layers* palette and give each a more readily identifiable name.) Now hide the original layer, then use a combination of the *Eraser* and selection tools to erase everything except those elements that sit in front of the birds.

3 The image is likely to be at an inappropriate scale when it's imported. Now we know we'll be scaling down we can finish the job of trimming off the unwanted pixels. Zoom in and use the *Eraser* tool at varying sizes to get into the nooks and crannies. Where there is an indistinct edge you can use softer-edged *Eraser* brushes and set *Opacity* in the *Options Bar* to about 40%.

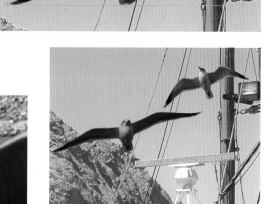

4 Next scale the image to fit. With the *Move* tool, point at one of the corners and drag inward. Hold down the Shift key as you do to make sure it isn't distorted. You can use the *Opacity* slider in the *Layers* palette to make the image partially transparent while you resize and move it about. Now perform these steps again to get the second bird in place.

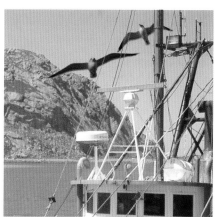

6 Move the layer with the trimmed rigging in front of everything else by dragging it to the top of the list in the *Layers* palette. You may need to do a little further fine-tuning of the layer to make it look right. If you're unsure about this, duplicate the layer and hide it before working on the copy. That way you'll have a copy to go back to and, just as importantly, compare against as you work.

Compositing multiple shots

7 Now that things are in place and scaled appropriately, we need to address the other problem frequently hit when combining images. The lighting on the birds doesn't match the lighting of the trawler photo particularly well. The trawler was photographed in strong sunlight, while the gulls were shot later in the day when the light was warmer. As a result, the whites look reddish by comparison and the contrast is noticeably lower. To correct the color issue use the *Hue/Saturation* controls, while the contrast is best tackled with *Levels*. But rather than do this directly to the image without any simple way of going back, use an adjustment layer for each change.

8 Go to *New Adjustment Layer* in the *Layers* menu and choose *Levels*. In the window that appears, click the *Group With Previous Layer* checkbox, or your changes will affect the entire document. Click *OK*, then move the left and right triangles that sit beneath the main section in the window that follows. Using *Levels* is a more flexible method than using the *Brightness/Contrast* option, but it does take a little more concentration. Drag the *Shadow* slider to the right to tighten up the dark tones, then drag the *Highlight* slider toward the left to lighten the pale shades towards white. Drag the *Midtone* slider to adjust the brightness of the tones in between.

9 Now add another adjustment layer, but this time pick *Hue/Saturation*. Remember to click *Group With Previous Layer*, then click *OK*. In the *Hue/Saturation* window that opens next, use the *Hue* slider to correct the color balance of the layer to match the general look of the main image.

10 If you want to alter one general color area without affecting the others, pick the appropriate color range from the pop-up menu at the top of the *Hue/ Saturation* window before dragging the *Hue* slider. Don't use the *Lightness* slider here, as this basically just flattens the image. You may find it worth knocking down the saturation a lot, then carefully painting the right color tints back in again with the *Paintbrush* set to *Color* mode and a low *Opacity*.

Convincing color can be achieved if you group adjustment layers with your new additions and leave the rest untouched. When all else fails, don't be afraid to use the *Sponge* tool.

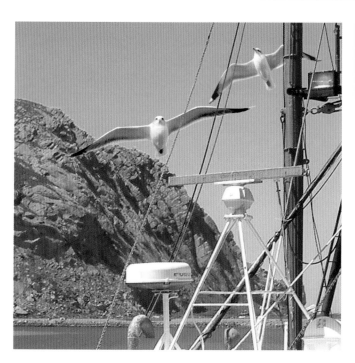

11 If a particular area proves difficult to manage, it can be worth knocking back the saturation directly. Rather than doing this for the whole layer via the *Hue/Saturation* window, use the *Sponge* tool to do this in specific areas. Make sure it is set to *Desaturate* in the *Options Bar*, then paint over an area in the image. The color saturation will diminish progressively as you do this. As gulls are essentially black, white, and gray, reducing the saturation one way or another is an effective solution to this specific compositing problem.

 TIP → If you keep a layered copy of the image, there is nothing to stop you flattening the layers and adding grain effects.

RECAP

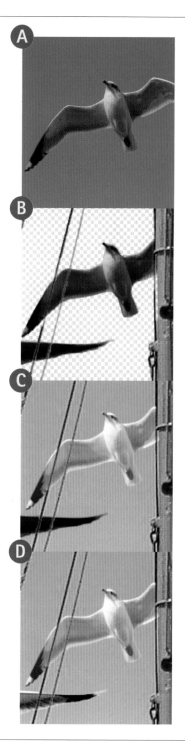

A Select wisely
If you want to enhance an image by compositing, select something appropriate.

B Layers
Place your object beneath other objects using the *Layers* palette. Turn visibility on and off as you work to make things easier.

C Tone
Group adjustment layers, and you can adjust the new material to fit the rest of the image.

D Final touch
Use the *Sponge* tool to get the color saturation just right, pixel by pixel.

4 Creative portrait retouching

One of the first things that springs to mind when you think about retouching photographs is the world of beauty and glamour. That mental connection is there for a reason; Photoshop and its competitors offer a wide range of methods to make people and their faces look better, some of which we will look at here. All of these techniques can be applied to any portrait, but they may require some patience. Restoring someone's youth is a little more art than science.

Reducing red-eye

Before

After

Red-eye is never a pretty sight, and is often responsible for ruining a perfectly good portrait. Although most cameras have a feature designed to eliminate red-eye when you take the picture, some of these work better than others and sometimes the setting isn't turned on in the first place. Luckily, it is something you can correct easily on the computer. Photoshop Elements and its main rivals have red-eye reduction tools built in.

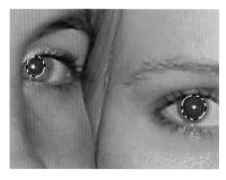

1 Start by duplicating the background image. Next, zoom right in on the eye, then select the *Elliptical Marquee* tool from the *Toolbox*. If it is not visible, click and hold on the *Rectangular Marquee*. A flyout will give you the option to change to the round setting, and you can also click on this option in the *Options Bar*. Since we don't want a hard edge, give the tool a 1- or 2-pixel feathering by going to the *Options Bar* and typing in the number in the *Feather* box. Remember that if you want to add the other eye to the selection, you need to hold down the Shift key.

2 Now that we have the selection, go to the *Toolbox* and click on the *Red-Eye Brush* tool. This looks like a paintbrush but also has an eye in the corner. Once this is clicked on, a variety of options shows up, including Brush *Size*, *Current* and *Replacement* colors, and *Sampling* settings. *Sampling* is the most important, enabling you to decide how the *Red-Eye Brush* first reacts to the colors of the eye. If set at *First Click*, then the first color clicked is the color that the brush will react to.

Red-eye is a perennial photographic problem, made worse by the fact that most compact cameras have the flash very near to the lens, causing a more direct reflection. Luckily we can remove the scarlet hue and keep the detail.

3 The *Tolerance* setting dictates how far outside the color the brush should affect. The *Sampling* setting can also be set to *Current Color*. This means that whatever color is in the *Current Color* box is the color it will affect. This color can be changed by clicking once in the color box next to the word *Current*. A *Color Picker* box will pop up and your cursor will change to an *Eyedropper*. Using the *Eyedropper*, select the red color from the eye and then click *OK*. You can also select the *Replacement* color in the same way if the default black does not give you the look that you want.

> **TIP** Your computer cannot tell the difference between eyes and other areas of color, so you can use the tool to brush away other colors in your images.

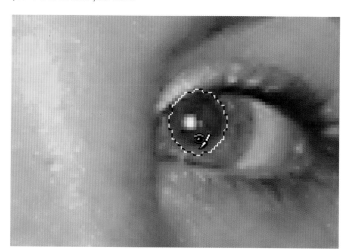
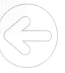

RECAP

A **Evil eyes**
Before you use the *Red-eye Brush*, it is a good idea to select the eyes so that you cannot run over and make a mistake.

B **Real eyes**
Once you've selected your replacement color, just paint away the problem.

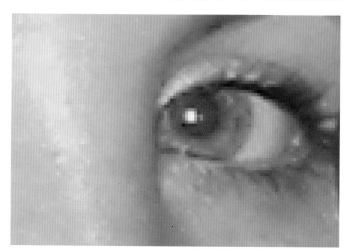

4 Once you have set your current color, just start painting away the red-eye. Because we have a selection around the pupils, we don't need to worry about the color changing anywhere else. The final result looks pretty good.

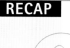

Accentuating eyes

When accentuating eyes, there is more to the task than simply whitening the whites. You may also need to add eyelashes, enhance the eyebrows and take out any stray hairs over the eyes. Bringing out the glitter in the eyes and sharpening them can also considerably improve the image. If there are any red lines in the whites these should also be removed. Changing eye color is rarely done but can be achieved with relative ease using *Hue/Saturation*. The trick is not to overdo the saturation in the eyes—you don't want them to look fake.

1 Open the image and duplicate the *Background* layer.

2 Create a *Levels adjustment layer* by selecting *Layer > New Adjustment Layer > Levels*. Fill the layer mask with 100% black so that nothing shows when you do

the correction. Do this by setting your foreground/ background colors to their default black and white. Select the mask and press Option-Delete (Alt-Delete). This fills the mask with the foreground color. Now change the blend mode to *Multiply*. Make sure that the mask is still active, then select the *Paintbrush*. Make sure that the brush has a soft setting and begin painting with the white over the woman's eyebrows. Painting with white removes the mask in that area only, so the eyebrows should get very dark. You will also notice if the brush goes off the eyebrows because the skin will turn a dark orange/pinkish color. Next select a smaller brush and do the same for the eyelashes.

3 As you can see, the eyebrows and the eyelashes are far too dark—lower the *Opacity* of the layer to about 40%. The eyebrows look fine here but notice that the eyelashes have almost disappeared again.

4 To add some sparkle to the eyes, you need to make a new layer. Instead of creating a new *Levels* adjustment layer, Control-click on the existing *Levels* adjustment layer's name (Right-click in Windows). A pop-up menu will appear with several options. Click on the *Duplicate Layer* option.

Eyes can make or break a portrait. A little time spent improving their appearance can pay dividends. Create a separate mask for the eyes, eyebrows, and eyelashes and add sparkle by adjusting their *Hue/Saturation*.

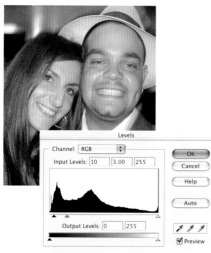

5 Fill the mask with 100% black so that the corrections disappear. Then make a mask for the pupils and fill with white to let the correction show through. Leave the *Opacity* of the layer at 40% and change the blend mode to *Soft Light*. The eyes will get cleaner and brighter. Now, double click on the *Levels* icon in the *Levels* adjustment layer to launch *Levels*. Set the *Midtone* input levels to 3.0 and the *Shadow* input levels to 10. This will darken the eyes up just enough to keep the brightness but make them appear a little less red.

6 If you want to change the eye color, you can do that now and still utilize the sparkle layer. Command-click on the sparkle layer mask to load it as a selection. Then make a new *Hue/Saturation* adjustment layer by selecting *Layer > New Adjustment Layer > Hue/Saturation*. Set the *Hue* to −150, the *Saturation* to −50, and the *Lightness* to −15 and click *OK*. With *Opacity* at 100% the eyes look a little strange. Lower the *Opacity* to 85% to get a more natural look and then change the blend mode to *Color* to bring back the sparkle.

RECAP

Ⓐ Masking
Create a mask for the eyes and carefully paint with a white color to enhance the eyes, eyebrows, and eyelashes.

Ⓑ Opacity
Lower the *Opacity* of the eyes to make them appear more natural.

Ⓒ Changing colors
Load the mask as a selection and adjust *Hue/Saturation* to change the color of the iris to blue.

TIP Accentuating eyes is not too difficult as long as you keep it simple. The more obvious the correction the more unbelievable it will be.

Whitening teeth

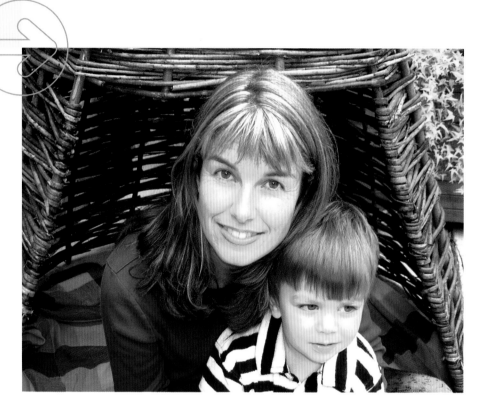

A popular facial correction is whitening teeth and eyes. It creates the appearance of brightness and openness in the face, which really enhances the image. Another enhancement is cleaning up the lips. This may involve fixing the lipstick, adding or removing highlights, or reshaping the lips slightly. There are many different ways to whiten the teeth. Adjustment layers allow you to tweak the result further if necessary. Do not make the teeth and eyes too white. They may appear too noticeable if they do not follow the overall tone and cast of the image.

1 Open up your portrait and zoom into the area around the mouth. Select the *Lasso* tool and make sure that there is an appropriate level of feathering. As always, this depends on the size and resolution of the image. In this case, 3 was about right. We're going to do the eyes and teeth separately because while both should be white, they differ in the finer coloration.

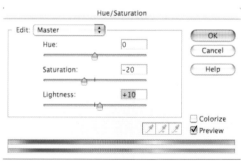

2 Once the selection is made, create a *Hue/Saturation* adjustment layer. Adjust the level of *Saturation* downward, taking it slowly. If you push the *Saturation* too far down, the gaps between the teeth look too gray to be convincing.

TIP Different people have different colored teeth, so try making individual adjustments to each subject in a group portrait.

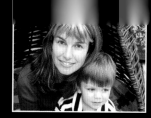

Image-editing software packages such as Adobe Photoshop Elements are ideal for removing blemishes and discoloration around the mouth and teeth. Without this facility, your subjects may not always look their best.

5 Create a *Levels* adjustment layer and enter 0.85 into the *Midtone* box for the *Input Levels* and click *OK*. Select the *Layer Mask* and fill with black by selecting *Edit > Fill* and setting it to 100% black and *Normal* blend mode. Once this is done, select the *Paintbrush*, set your foreground color to white, and extend the color to the bottom corners of the lip. Once again this correction seems minor but, together with the eyes and teeth, it really brings about a change in the face.

3 Create a selection for the whites of the eyes, also using the same setting for the *Lasso* tool. Create another *Hue/Saturation* adjustment layer and set the *Hue* to 65, the *Saturation* to −50, and the *Lightness* to 30.

4 Now to the lips. Select the *Background* layer and the *Clone Stamp* tool. Set its *Opacity* to 75%. Set your source point by Option-clicking (Alt-clicking) on an area adjacent to a crack in the lips, but not close enough for the source to interfere with the brush. Once this is done, start lightening the cracks. You don't want to remove them completely because it will make the lips appear plastic.

RECAP

Ⓐ Selections
Create separate selections in turn for the eyes and the teeth.

Ⓑ Whitening
Use *Hue/Saturation* to whiten the teeth and eyes. Then use the *Clone Stamp* tool to remove or lighten the cracks around the lips.

Reducing age

2 Select the *Clone Stamp* tool and in the *Options Bar* check the *Aligned* and the *Use All Layers* boxes. Set your source point by Option-clicking (Alt-clicking) an area that you want. This is usually very close to where you will start cloning. Make sure that the source point and the brush do not get too close or else you'll start to see some patterns forming as you clone.

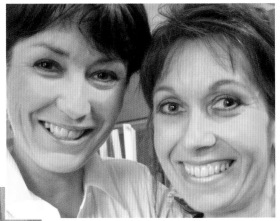

Have you ever had your picture taken by someone and noticed that you have aged a little more in the face than you realized? All of a sudden the wrinkles around the eyes and mouth seem to be more prominent. Lines and wrinkles can be easily removed—the difficulty lies in not overdoing it! The primary tools for wrinkle removal in Photoshop Elements are the *Clone Stamp* tool, the *Airbrush*, and the *Paintbrush*. Adobe Photoshop also offers the *Healing Brush* and *Patch* tools—these make the job easier but you can get by without them.

1 Start by opening up your shot and making a new blank layer by clicking on the paper icon at the bottom of the *Layers* palette.

3 Set *Opacity* to around 75%, or if you prefer, set it to about 25% and make repeated brushstrokes to achieve the look you want. If using the higher density, you will need to adjust the *Opacity* up and down accordingly. Select an area to fix such as the crow's feet. You will need to use a different technique for the slight bags under the eyes.

4 For the bags use a *Levels* adjustment layer and *Lasso* selections. Begin by making a selection around the bag under the left eye of the woman on the left. When complete, feather it by selecting *Selection > Feather* or by pressing Option-command-D. Input a value of 15 and press *OK*.

TIP If you use a pressure-sensitive graphics tablet, turn off tablet support when using the *Clone Stamp* tool.

Digital photography allows you work wonders—and win friends. Using a combination of adjustment layers, the *Clone Stamp* tool and the *Paintbrush*, you can take years off a subject by removing lines and wrinkles.

5 Make a *Levels* adjustment layer. In the RGB setting, move the *Midtone* input slider to the left a little, then move the *Shadow* output slider to the right until it reads 20. This will open up the lighting under the left bag. We do not want it to go so light that it has a different hue to the rest of the area surrounding it. We need, therefore, to go in and adjust the color to match.

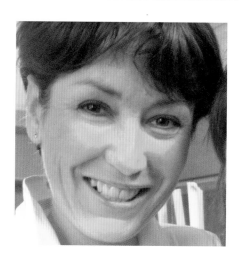

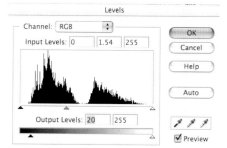

Levels

Channel: RGB

Input Levels: 0 1.54 255

Output Levels: 20 255

☑ Preview

OK
Cancel
Help
Auto

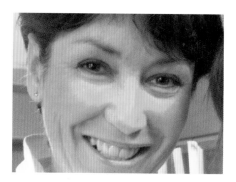

6 Double click on the *Levels* icon in the *Levels* adjustment layer you created earlier. In both the *Green* and *Blue* channels move the *Midtone* slider up a little. On skintones this should bring the hue back down to the same level as the surrounding area.

Levels

Channel: Green

Input Levels: 0 0.85 255

Output Levels: 0 255

☑ Preview

OK
Cancel
Help
Auto

7 Notice that when you made the selection in step 4, a mask was automatically created for your *Levels* adjustment layer. Select the layer and, with your foreground set to white, use a medium-opacity

brush to paint over the bags under the other eyes. You should see the effect of the adjustment layer. You can also do this around some of the heavier lines around the mouths. Your mask layer thumbnail will end up looking something like this, and the worst signs of aging will be gone.

RECAP

Ⓐ New Layer
Create a new adjustment layer and select a source point for the *Clone Stamp* tool. Gently remove any prominent lines.

Ⓑ Removing bags
Change the lighting beneath the eyes with a new adjustment layer.

Ⓒ Recoloring
Adjust the coloring of the areas you have changed in the *Levels* dialog box.

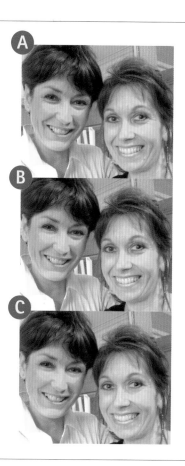

Reducing facial glare

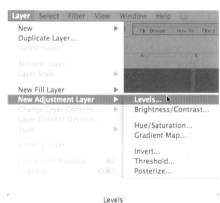

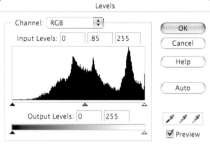

A few highlights are always welcome on a formal or informal portrait, as they add life and interest to the picture. When the effects of light and flash go too far, however, a slight glare can sometimes result. Getting rid of facial glare can be tricky: it's very difficult to select the affected areas because their edges are so soft, and any hard line on a mask is going to show. There are two ways to fix this in Photoshop Elements. You may need both, as glares can't often be treated in exactly the same way.

1 To reduce facial glare either brush on the correction or isolate each one with the *Lasso* tool. If you have a tablet and pen I would recommend brushing on. Mouse users should isolate each glare using the *Lasso* tool, taking several attempts to pick an area using different levels of feathering. I suggest drawing with no feathering, then selecting the feathering afterward, as this will save you from having to redraw the selection each time you change the feathering. Since all the glares are different, this will give you a good idea of what to use on the others and will save guesswork later.

2 Select the *Lasso* tool from the *Toolbox*. Since there are no hard edges I suggest using the freehand *Lasso*. For this area I have made a selection with a *Feather* set at 8. Notice that I have made the selection slightly larger than the area to be corrected. The feathering will protect the darker area somewhat, and allow a smoother transition.

3 Now make a *Levels* adjustment layer. Adjust the *Midtone* input slider to the right until you see a hard edge starting to appear. At this point use your up and down arrows to fine-tune the correction from, in this case, 1 down to 0.85. Doing this on a separate layer will allow you to look at all the corrections together and adjust the correction or the mask accordingly.

Some of the best snaps need to be taken quickly with a built-in flash, so there is always the risk of glare. Luckily we can easily set up adjustment layers to tone the glare down, or paint over it.

USING LEVELS

The other way to do this is to make a *Levels* adjustment layer, go overboard on the change on an overall level, but brush it in only where it is needed. Create your *Levels* adjustment layer and adjust the sliders so that highlight areas lose their excessive shininess. Don't worry if the rest of the image looks dull; won't be affected by our changes later on. When the layer has been made the layer mask is all white, which lets the correction through to the image. Select the mask by clicking on it once and set your foreground color to black. Under the Edit menu go *Edit > Fill*. This brings up a dialog box that gives you the option to fill with the foreground or background colors, a pattern, or various shades of white, black, or gray. You can also change the *Opacity* of the fill. For now fill with the foreground at 100% black. Your big overall *Levels* correction will now disappear behind the mask.

2 Make sure that you are using a very soft brush. Flip the foreground and background colors so that the foreground is white and start brushing in the corrections onto the mask. To quickly change the *Opacity* of your brush, just type in the number you want. For example, 2=20%, 0=100%,12=12%. If you go too far with the brushstroke and too much color is coming through, just start painting in with black to cover it up a little.

4 You can also see that with this technique an overall adjustment will fix some but not every area of glare. Some of these areas will need an additional tweak. The good news is that all you need to do is duplicate your *Levels* adjustment layer and paint in the parts on the mask that are glare free. Now adjust the correction to fit by changing the *Levels* settings or changing the *Opacity* of the layer.

1 If you have a graphics tablet, set the *Preferences* to recognize pressure. This allows your brush strokes to vary without having to change the opacity with each stroke. To do this, go to the *Options Bar* and click on more options. At the bottom you will see a radio button for *Tablet Support*. Click on the radio button to make it active. If you have a mouse or a touchpad you will have to change the density with each stroke.

More Options:

Spacing:	25%
Fade:	0#
Color Jitter:	0%
Hardness:	0%
Scatter:	0%

Angle: 0°
Roundness: 100%

☑ Tablet Support

3 Doing the corrections with brushstrokes allows you to keep everything on one individual layer, making it easier to edit any further corrections. You don't have to guess which layer is which correction.

Improving complexion

Before

After

Everyone has slight skin blemishes from time to time. Fortunately, removing blemishes is probably one of the quickest and easiest fixes that can be made to a portrait. One method is to use the *Clone Stamp* tool. Another is to use the *Dodge* and *Burn* tools. These tools are great for cleaning up blemishes in Photoshop Elements and even better in Photoshop because of the access to individual color channels.

1 Blemishes don't just affect teenagers and adults. This young boy's face has a few unfortunate scratches and bruises. We'll get rid of them without even resorting to the *Clone Stamp* tool.

2 Select the *Dodge* tool, set the *Range* to *Shadows* and the *Exposure* to 5%. Make sure you have a very soft brush. Set this by holding down the Shift key and pressing the { key to soften the brush. Press the } to harden the brush.

TIP As always, try to keep to a low *Opacity* when retouching. This will avoid pixelation artifacts occuring and help to keep your adjustments invisible.

3 It's best to use a small brush for this job, as an oversized brush will really show on the skin where it isn't needed. Carefully paint over the area of the blemish, but don't try to remove it completely—it will turn white if you go too far. A nice light pink will suffice.

You can use any image-editing program to easily remove spots and blemishes from a portrait. Use the *Dodge* tool to brush away the blemish or cut and paste an area of clear flesh over the imperfection in a new layer.

Levels

Channel: Green

Input Levels: 0 1.26 255

OK
Cancel
Help
Auto

Output Levels: 0 255

☑ Preview

Levels

Channel: Blue

Input Levels: 0 1.04 255

OK
Cancel
Help
Auto

Output Levels: 0 255

☑ Preview

TIP A third method of removing blemishes is to use the *Clone* tool—remember to keep the *Opacity* low.

RECAP

Ⓐ Dodge
Select the *Dodge* tool and use a small brush to paint over the blemish.

Ⓑ Recolor
Create an adjustment layer and change the selected blemish in the *Layers* dialog panel.

Ⓒ Layer
Alternatively, use *Layer via Copy* to overlay a clear area of flesh over the blemish.

4 Now make a selection around the remaining pink area. Feather it with a setting of 5 then create a new *Levels* adjustment layer. In the green channel there is one mound of black showing the pink area. Move the *Midtone* input slider until it reads 1.26. This will put the arrow a little past halfway through the black. Then go to the *Blue* channel. That same mound is there, but this time you should only slide the *Midtone* slider to the right edge of the black. It should read about 1.11. The pink area should be gone now, as well as the blemish.

Layers More ▶

Normal Opacity: 100%

Lock: ☐ 🔒

👁 ✏ Layer 1

👁 Background 🔒

Deselect
Select Inverse
Feather...

Layer via Copy
Layer via Cut
New Layer...

Free Transform

Fill...
Stroke...

Last Filter

✓ Close Palette to Palette Well

Help Contents
Help

New Layer...
Duplicate Layer...
Delete Layer
Delete Linked Layers
Delete Hidden Layers

Rename Layer...
Simplify Layer

Merge Down
Merge Visible
Flatten Image

Palette Options...

5 Another way to get rid of certain types of blemish is to patch them with a piece of compatible flesh tone. Make a selection around the red bumps on the chin. Feather it again to a setting of 5 and then move it to a clean piece of flesh by dragging from the center. Holding down the Control key, click within the selection at the clean spot and choose *Layer via Copy* (Right-click to see the menu in Windows). Using the *Move* tool, move the patch over the blemish and merge the layer down by going to the pop-up menu at the top of the *Layers* palette and choosing *Merge Down*.

Facial reshaping

Sometimes camera angles produce shots which are less than complimentary to their subject. Although models may protest that their shots are unmodified, it is very rare for a professional photo of a model to be left unretouched. However, this doesn't mean lengthy, difficult work. Camera lenses can make subjects look oddly distorted at times, despite recording just what they "see." Eyes or noses may appear at the wrong angle, and even a slim face can pick up extra visual weight under the jawline. These problems of perception can be fixed easily with the *Liquify* filter.

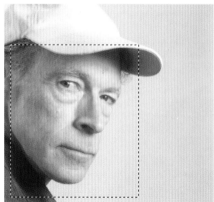

1 To start with, duplicate the initial *Background*. This ensures a copy of the original is kept for comparisons. It is all too easy to push distortions too far without realizing it if you have no easy way to compare against the original. Select an area to distort (this can speed up the filter's processing), enclosing the whole face and some room around the outside as well. Always give yourself lots of room and view all the features when doing this kind of work.

2 Go to *Distort* in the *Filters* menu and and open the *Liquify* filter. The first thing is to make the nose look a little less flared. The back of the nostril that we can see is fairly large, so we need to close it down slightly and also move the rear of the outer nostril across to the right a little. This will make the nose subtly less flared. Zoom in to 100% then, using the first brush in the list, set the *Size* to around 90 to bring the flaring nostril down, and a *Size* of around 60 to bring the back of the nose gently forward.

3 When you're happy with the result, click *OK*. Back at your image window, toggle the visibility of the adjusted layer

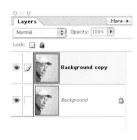

to compare it with the original. If you've done this well the older version should look more like a distorted photo than the new one, although the difference should be fairly subtle.

Small adjustments to a subject's facial features can make a world of difference in the overall impression. Fortunately Photoshop allows you to squeeze and push areas of the image around to achieve this easily.

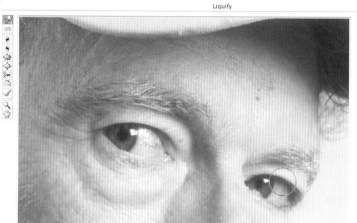

TIP Check your brush size. Too small, and you'll end up pushing lumps around the image; nothing will remain smooth and realistic. Too large, and you'll find it hard to shift just the target areas.

4 The eyes are a little on the sleepy side, so we'll tackle that next. Make sure the selection generously encloses this area, then go back to the *Liquify* filter. Using a brush big enough to avoid pushing small lumps of image around, but small enough to give accurate control, lift the top eyelids up and the bottom ones down a little. Keep the natural curve of the lids. Feel free to tackle lifting the bags under the eyes a little, too, although fading these separately will also help.

5 Finally, use the *Liquify* filter again to make the grin a little more friendly. Lift the ends of the mouth upward a little, making sure to match the barely-visible side to the one in clear view. Once done, toggle the before and after layers to get a feel for how much you've remodeled this face. It is subtle, but it really is there.

RECAP

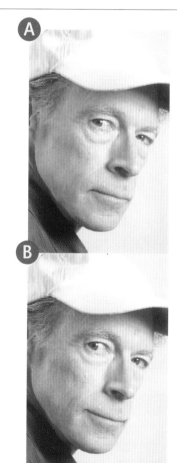

Ⓐ Suspicious
It doesn't take a lot for a shot to look unflattering. Here the subject's left eye and lips seem a little unfriendly.

Ⓑ Welcoming
Use the *Liquify* filter's tools to push them gently to a more flattering shape.

Glamour

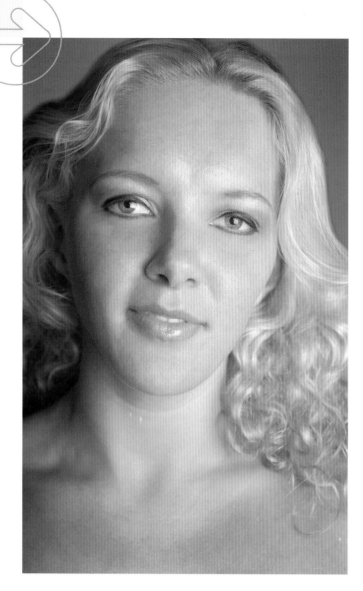

The best aspect of digital manipulation is that you can do as little or as much as you want. Anything can be retouched, including stills of objects from food to cosmetics, but one of the most common subjects for both commercial and amateur retouching is the beauty or glamour shot.

1 Some retouchers will do a markup on the image in a separate layer to decide what needs to be done. Let's do a list: change the background to the *warm gray 10* preset, then clean and whiten the eyes and teeth. Sharpen the eyes, thin the face and clean up any blemishes. Clean up the marked flyaways in the hair and at the forehead. Get rid of bags under the eyes and lessen the mouth lines. Push up the left side of the mouth to get more of a smile. Phew! Time to start.

2 Everything that we've mentioned here has been gone over in previous sections of the book, with the exception of the hair fixes. Duplicate the background layer and start by slimming down the face. If there is going to be any masking, it's best to get any distortions out of the way first. Make a selection around the face and launch the *Liquify* filter by going to *Filter > Distort > Liquify*.

TIP Once you know what needs doing, plan an order of steps in your mind so you won't undo your own work.

Retouching has many fun and serious purposes, but none more popular than making an image look more glamorous. Following a sensible plan of action we can apply all the skills in this book to get a great, believeable result.

3 Once in *Liquify* set your brush to a size large enough to push all or most of one side of the face in at the same time. Start by gradually moving the cheeks inward. You don't want to make a drastic change here. Once this is done you will need to move the chin to the left very slightly.

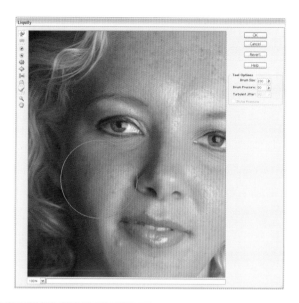

5 Now that's done we can take away some of the flyaway hairs. The easiest method here is to use the *Clone Stamp* tool. Make sure the result has a defined, but not unnatural edge—borrow from the background or the hair, but if you do clone from the hair, take care to clone from an area flowing in the same direction.

6 The next step is to neaten the hairline on the forehead in the same way.

4 While we're using *Liquify*, we can also slightly lift the left of the mouth and lower the right to fit in better with the new cheekbones. It's important to get any distortion of the original image out of the way before we add any changes that apply to just one area of the image. Otherwise, moving the background could leave any patches on newer layers looking lost at sea.

Glamour

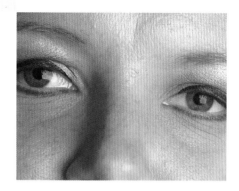

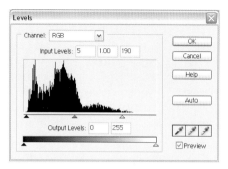

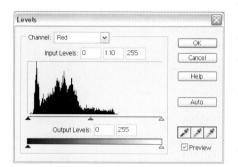

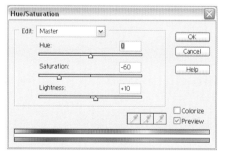

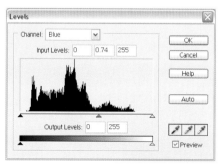

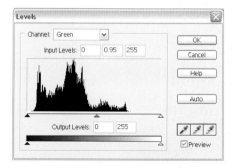

7 Make the eye whites whiter and a bit brighter. Use the *Lasso* tool, with a 5-pixel feather, to make a selection around the eye whites, then create a *Hue/Saturation* adjustment layer. Set the *Saturation* to -60 to remove unwanted color and push the *Lightness* up a little.

8 Now whiten the teeth using the same method but using a -10 *Hue* and moving the *Lightness* up to an appropriate level (around 20 should do the trick). If you find that you lighten up a little of the lips too, you can always paint onto the mask in black with the *Brush* tool.

9 The irises of the eyes are supposed to be a light green. Make a selection around the iris and pupils of the eye, then use an adjustment layer to change the color. Here a *Levels* adjustment layer is used for added control, with the *RGB* channel's *Highlight* slider moved down a long way, then the *Midtone* sliders nudged in each separate color channel (*Red* to 1.10, *Blue* to 0.74, and *Green* to 0.95). You can use any method you're comfortable with.

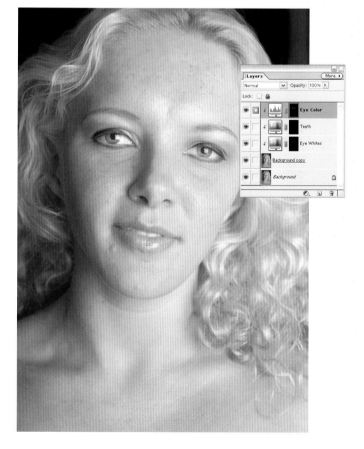

Using carefully masked adjustment layers we can achieve stunning results with the eyes, pupils, and teeth. Subtlety is the watchword—too much change will stand out.

Glamour

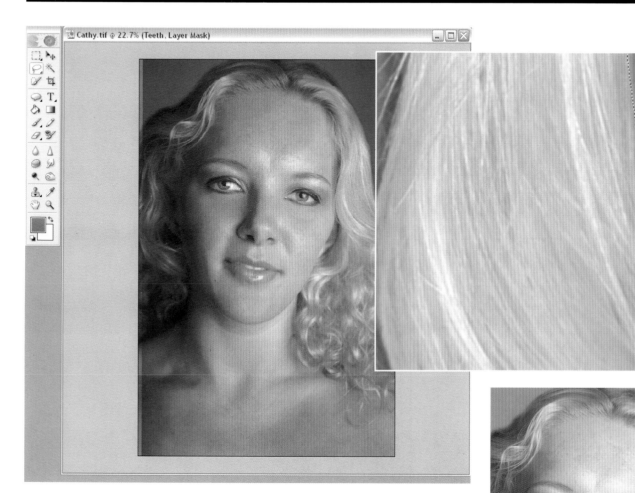

10 In order to create an adjustable background color, select the areas of background then go to *Layer > New Fill Layer > Solid Color* and then pick a color. Here a warm gray of R118, G110 and B103 is used. If the edge looks odd afterwards, you can always touch up the mask.

11 Now is the time to remove all the little blemishes and wrinkles. This is a process of careful cloning, as we've seen earlier. Set the *Clone Stamp* to a medium *Opacity*, and reduce and enlarge the brush with the [and] keys to match the size of the object you are working on.

TIP If you are using Photoshop this job is made easier using the *Extract* filter, which helps select uneven areas (like hair).

Glamour

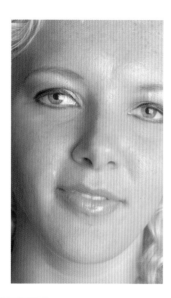

12 Remember to keep zooming in and out as you do this. By looking at the whole image it's clear that concentrating on the individual wrinkles and pimples meant the bags under the eyes were neglected.

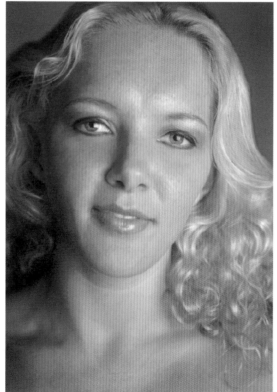

13 There are no rules here—you can do as much or as little as you like, so long as you take care not to create repeating patterns (bands) with the *Clone Stamp*. Sometimes wiping over large areas of skin with the *Blur* tool, set to a low *Opacity* can soften them as well.

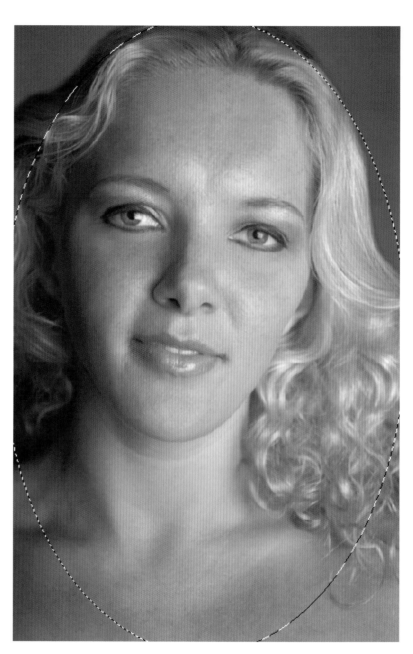

14 Finally it's time to do something to spice up the image, just a little. First select an ellipse around the whole image using the *Elliptical Marquee*.

TIP When using the *Clone Stamp*, remember that a soft-edge brush can remove texture from an image.

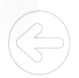

As a final stage to any facial retouching, the *Clone Stamp* tool can be employed to remove blemishes and wrinkles. The *Blur* tool can also be used to soften specific areas of the face.

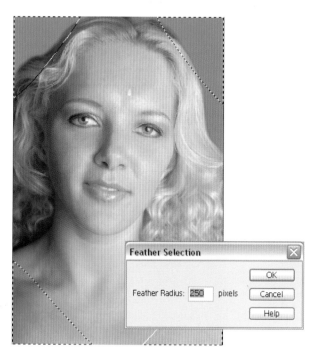

Feather Selection

Feather Radius: [250] pixels

OK
Cancel
Help

15 Now feather the ellipse by 250 pixels 3 times in a row by pressing Option-Command-D (Ctrl-Alt-D) and typing in 250 then repeating the step twice. You'll see the shape change as you do this. Invert the selection so just the corners are selected by pressing Command-Shift-I (Ctrl-Shift-I).

16 Finally, create a new levels adjustment layer called 'Vignette'. Don't adjust the levels, but set the blend mode to *Multiply*. The mask partially protects the face, less so toward the edges, and the whole image gains some depth and color.

RECAP

Ⓐ Planning
The first stage of any glamour project is to consider your actions. Plan in your mind what tasks will require which tools as some, like reshaping with *Liquify*, are better accomplished first. Others, like detailed *Clone Stamp* work, can wait until last.

Ⓑ Enhancing
After adjusting the lips and cheeks slightly with the *Liquify* filter, we can use masking and adjustment layers to bring out features like the eyes and lips, knowing that we will not be altering their shape again.

Ⓒ Wrinkles and spots
Finally the *Clone Stamp* tool can be applied to any disfiguring blemishes, and used to wipe away wrinkles.

5 Hand-coloring techniques

Coloring images is always an artful endeavor. Sometimes shots that are taken in color would work better in black and white, as a sepia tone, or a mixture of both. There are also duotoned, tritoned, and quadtoned images that look great but may sometimes be difficult to print. Both Photoshop Elements and Photoshop are good for creating these variations. We also look at variations on the basic sepia tone, using colors such as blue and black, or blue and sepia.

Black and white

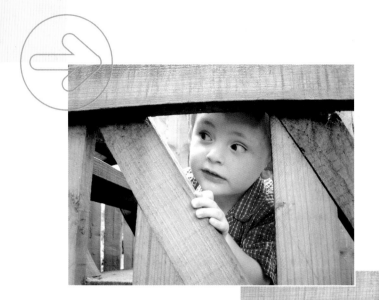

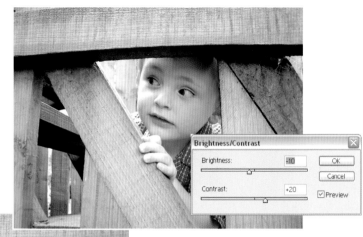

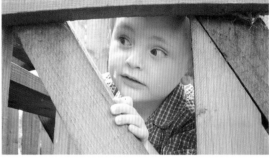

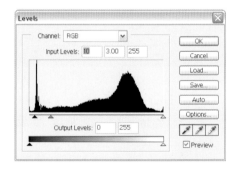

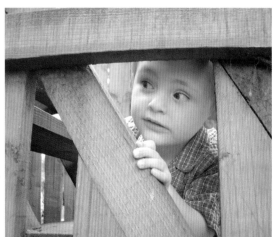

In any graphics program, going from color to black and white appears simple but to get it right can be tricky. It's rarely a case of going from whatever color mode you start out in and just converting the image to grayscale. While the image will lose its color, it will also lose its depth, its full range of tone, and a certain amount of detail. The way to avoid all of this is to do all your adjustments to the image first and then convert.

1 After duplicating the image, create a new *Hue/Saturation* adjustment layer, and turn the master *Saturation* slider all the way down to –100. This will remove all the color from the image. Next, change the blend mode of the layer to either *Saturation* or to *Color*. This will accomplish two things. It will bring back some of the contrast from the original image and also soften it slightly.

2 Now select the *Background* layer, then create a new *Brightness/Contrast* adjustment layer. The actual settings will depend on the image, but you should adjust the image so that it looks right to you.

3 With some photographs, it works better if you use a *Levels* adjustment layer instead. You can always create both and toggle their visibility on and off to see which works best before deleting one or the other. What is important is that the new adjustment layer must sit below the *Hue/Saturation* layer created earlier, otherwise there will be some loss in the gradation of the image. This could either be plugging in the shadows or flattening around the quarter-tone areas. Once you have the image adjusted as you want it, flatten the layers. You can either leave the image as a three- or four-color black and white or you can convert to a grayscale image.

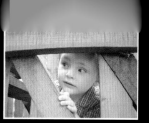
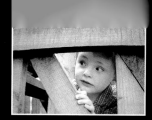

Black and white photography has long since stopped being the only choice available, but it can still lend a subject more weight and drama. Converting to black and white is easy, but getting it right requires a few extra moments.

GRADIENT MAPS

Another way to convert to black and white is to use a *Gradient Map* adjustment layer.

1 First set your foreground/ background colors to the default black and white.

2 Next, create the *Gradient Map* adjustment layer.

3 When the *Gradient Map* dialog box pops up, click on the *Dither* box in the *Gradient Options* panel.

4 The picture will now be in black and white; but we're not finished yet. Instead of clicking on the *OK* button, click once on the gradient in the box and a *Gradient Editor* dialog will appear. Clicking on the black arrow that points upward in the bottom left of the dialog box will show a midpoint in the gradient. It will look like a diamond. Right now the image looks flat. Slide the diamond to the left to open the image up from the midtones.

5 Moving the diamond's location to 45 will give the image a little more detail. Once that is done, move the black arrow over to the right to enrich the shadows. Moving it to a 4 should do the trick but you risk plugging up the shadow end. Now keep on clicking *OK* until all the dialog boxes are gone, then save.

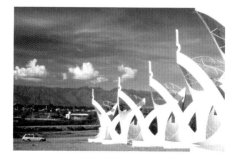

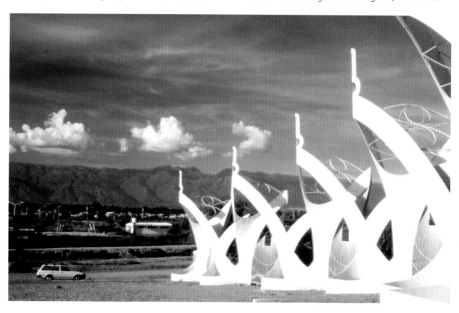

Selective coloring

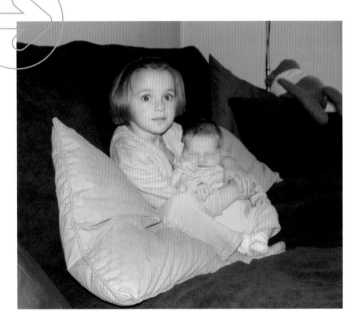

Creating pictures that are predominantly black and white but which have a splash of color is very popular. Used well, it has a strong visual appeal. There is nothing like color to draw the eye to a focal point—with a touch of clever masking you can achieve some intricate work. To achieve this look, you use a similar technique to the one used in the previous project—converting a color image to black and white. Since you want to keep the focus primarily on the color area of the image, however, it is not always necessary to have a very detailed black and white area of the image.

1 To begin, use the *Lasso* tool to select the area that you wish to remain colored. You now have two choices: you can either save the selection or you can place it immediately on its own layer. Whereas placing the area on its own layer will give you the colored portion of an image, it is not always ideal if you wish to adjust the edges in any way. It is a good way, however, of saving a selection without having to go to the *Save Selection* menu. If you do put the selection on its own layer, turn the visibility off for now.

2 Once you have saved the selection, create a *Hue/Saturation* adjustment layer and move the master *Saturation* slider all the way to −100 to remove all the color. This isn't the best way to turn a color image into a black and white one, but we're not concerned about capturing every tone at this stage.

TIP When using the *Lasso* tool press Option-shift (Alt-shift) to easily add or subtract from a selection.

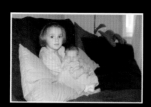
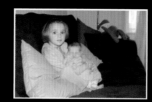

Combining color with black and white imagery is a creative means of highlighting the subject of a photograph. Use layers and selections to achieve this striking effect.

TIP Print out images frequently at a low resolution to see if your color changes are working correctly. Printing at a low resolution will keep your ink usage to a minimum.

3 The advantage of placing the color portion on its own layer is that all you need to do now is turn on its visibility. You can also adjust the *Opacity* of the layer to get a softer feel to the color portion.

4 If, you took the *Save Selection* route, load the selection, then click on the *Hue/Saturation* adjustment layer's mask to select it. You can fill with black now to give you the same result as the layer option at 100%. Or you can feather the mask for a softer outline around the area and then fill with black. This is a 100% black fill over a completely white mask, with a small feather around the subject.

5 You can also fill with black at various percentages to achieve the same look as a lowered layer *Opacity.* Do this by using the fill dialog box under *Edit > Fill.*

RECAP

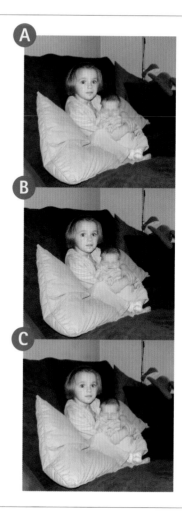

Ⓐ Make a selection
Use the *Lasso* tool to select the area you wish to remain colored. Next, place the selection in its own layer.

Ⓐ Remove color
Create a *Hue/Saturation* adjustment layer and remove the color from the area that you wish to keep black and white.

Ⓐ Adjust opacity
Adjust the *Opacity* of the colored layer to soften its appearance.

Coloring black and white

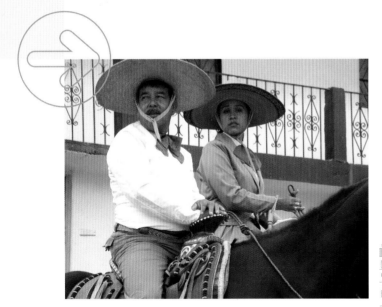

Despite what the purists will tell you, some black and white images do benefit from a degree of coloring. You can use vivid colors or an old-fashioned color wash style. Either way, there are certain steps that can make the process a lot easier. Most importantly, plan ahead: select your color palette and decide how you are going to achieve your colored effect. Do you intend to group all the flesh tones onto one layer or are you going to leave each figure's flesh coloring separate? Are you going to paint the image freehand or block it off in selections? Decide on the brushes you will be using and build your own brush palette if necessary. All these things will speed up the process.

1 Open up your image and add a new color layer by clicking on the paper icon at the bottom of the *Layers* palette; then change the blend mode to *Color*. Set your foreground color to a shade you have selected in the *Swatch* palette.

2 Here we begin work on the horse— the color used was R66 G22 B0. Select the *Paintbrush* from the *Toolbox* and, using a slightly soft edge, begin painting the horse. You will see that the color seems a little too bright or maybe unnatural. That's *OK*.

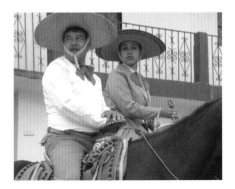

3 Duplicate the layer when you are done by dragging the layer to the paper icon at the bottom of the *Layers* palette. Change the blend mode to *Vivid Light* and lower the *Opacity* to 40%. The horse is now a rich dark brown. Go ahead and colorize the saddle to whatever you think appropriate.

4 To give an indication of how your color will look as you go along, and to help bring out some depth, duplicate the *Background* layer and drag it to the top of the *Layers* palette. This should now be the topmost layer. Change the blend mode to *Soft Light*. Leave this layer turned on and build your other layers underneath it as you proceed.

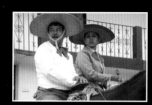
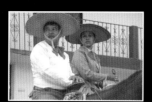

Adding color to a black and white image can produce dramatic results. This is best achieved using adjustment layers with a variety of blend modes: a complicated task that most image-editing packages handle with ease.

5 Create another color layer and start working on the man. For his trousers use R69, G25, B21. Paint at 100%. For the tie use R46, G49, B146 at 100%. For the hat use R140, G98, B57, and also *Paint* at 100%. For the flesh use R253, G198, B137 and paint at various opacities.

6 Create another color layer for the woman. Use the same or similar flesh values as you did for the man. Select colors for the rest of the clothes. Try using a very lightly feathered *Lasso* selection and the *Paint Bucket* for some of the coloring.

7 Create another color layer for the sky. Using the *Lasso* tool with a feathering of 2 select around the railings. Click on the *Background* layer and then choose the *Magic Wand* tool. Holding down Option-shift (Alt-shift), click on the sky. Only the sky should be selected now. The Option-shift key command tells the *Magic Wand* to pick only the values clicked on within that selection. A small "x" will appear next to the cursor when you do this. Save this selection by choosing *Select > Save Selection*.

TIP The *Swatch* pallette offers a range of pre-defined colors. You can create your own custom colors, however, by choosing a color from the picker and giving it a name.

8 With the sky selection active, click on the *Gradient* tool and choose *Linear Gradient*. For the foreground choose a light sky color—say R46 G49 B146—and leave the background white. Drag a gradient from top to bottom over the selection to create the sky. Lower the *Opacity* of the layer to 45% and change the blend mode to *Multiply* or, as here, *Hard Light*. Painting in color on a black and white image can be a long process but the end results are striking.

RECAP

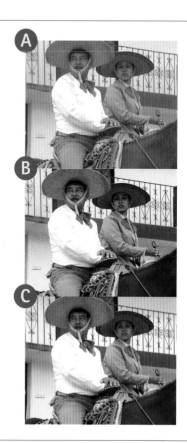

Ⓐ Set the foreground
Create a new color layer and set its blending mode to *Color*. Choose a foreground color from the *Swatches* palette.

Ⓐ Layer upon layer
Repeat the process of creating a color layer and painting a chosen area in a specific color.

Ⓐ Making the gradient
Use the *Gradient* tool to create the sky.

Creating sepia tones

There is something about the
old-time look that appeals to many
people. In fact, many digital cameras
now include a sepia setting for this
reason. But what if you took a shot in
full color or in black and white? There
are a lot of options to tint pictures
in most manipulation programs. Some
are straightforward and others are
multiple-step processes that yield
greater depth in the image. The
technique that you use depends upon
the effect you are hoping to achieve,
and the color or dynamics of the
original image.

1 In Elements
there is a
quick way to create
a sepia-toned image.
The first step,
whether you are
working from color
or black and white,
is to duplicate the
Background layer.
Next select *Enhance
> Adjust Color >
Remove Color*. This is
the same as opening
Hue/Saturation
and moving the
Saturation slider all
the way to the left.
The image should
now be gray.

The sepia-tone print is an evergreen favorite among photographers. It can add mood and atmosphere to an image. Most image-editing programs will allow you to create your own sepia-toned prints within minutes.

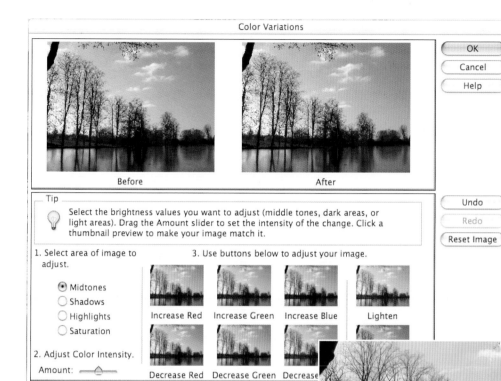

Color Variations

OK
Cancel
Help

Before After

Undo
Redo
Reset Image

Tip

Select the brightness values you want to adjust (middle tones, dark areas, or light areas). Drag the Amount slider to set the intensity of the change. Click a thumbnail preview to make your image match it.

1. Select area of image to adjust.
 - ⦿ Midtones
 - ○ Shadows
 - ○ Highlights
 - ○ Saturation

2. Adjust Color Intensity.
 Amount: ———△———

3. Use buttons below to adjust your image.

Increase Red Increase Green Increase Blue Lighten

Decrease Red Decrease Green Decrease

TIP Use this method for creating sepia-toned photographs to make images with other colorings. You can tint a picture any color you like.

3 Another way to do this is to use *Levels* and to increase the red and decrease the blue using the *Midtones* slider. *Levels* has a tendency to saturate the image. If this is undesirable, you can adjust the colors down or use *Hue/Saturation* and take the *Saturation* down a little.

2 At this point there are two ways to go about coloring the image. The first way is to use *Color Variations*. Go to *Enhance > Adjust Color > Color Variations*. With the settings at the default, click once on the *Increase Red* and once on the *Decrease Blue*. Even though this move is made from the midtone, it will affect the whole image at this setting. If this effect is too strong or weak, press the *Reset Image* button to undo the changes. Now slide the *Amount* slider to the left to diminish the correction or to the right to increase the correction.

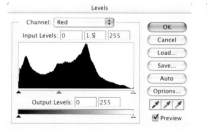

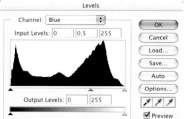

Levels

Channel: Red
Input Levels: 0 | 1.5 | 255

OK
Cancel
Load...
Save...
Auto
Options...

Output Levels: 0 | 255

☑ Preview

Levels

Channel: Blue
Input Levels: 0 | 0.5 | 255

OK
Cancel
Load...
Save...
Auto
Options...

Output Levels: 0 | 255

☑ Preview

Duotones

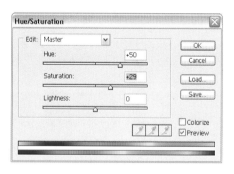

For years, photographers and makers of fine art prints have used duotones to add a touch of depth to monochrome images. By printing using black and an extra color—usually brown—you can add warmth of tone to a black and white shot. Adobe Photoshop has built-in support for duotones and can also easily create tritones (with two extra colors) and quadtones (three extra colors). This is not so straightforward in Photoshop Elements. You can fake the effect using a similar technique to the one used in the creation of sepia tones—the steps here, however, will only work in Photoshop.

1 Open and duplicate your image and set your foreground/background colors to the default black and white by clicking on the little black and white squares at the bottom of the *Toolbox* next to the foreground/background squares.

TIP Any RGB or CMYK image can be used to create a duotone. The file needs to be converted to grayscale first however.

2 Create a *Gradient Map* adjustment layer by going to *Layer > New Adjustment Layer > Gradient Map*. When the *Gradient Map* dialog box shows, click on *Dither* and then click on the gradient in the window. Adjust the *Shadow* and *Highlight* sliders till you have a look and feel that you like and hit *OK*. In this example the sliders were left at their default.

3 Change the blend mode or the gradient map layer to *Color*. This will give it a softer feel. Now create a new *Hue/Saturation* adjustment layer underneath the gradient map layer and move the *Hue* sider to 50 and the *Saturation* slider to 29. This will bring in some detail to the sky while adding a little contrast to the foreground. If you don't want to change the foreground at all, instead of moving the sliders for the *Master* channel, go to the *Cyan* channel and slide the *Hue* to about 30 and the *Saturation* to 100. This will affect only the sky.

4 When you have the look that you like, select *Image > Mode > Grayscale*. A dialog box will ask if you want to flatten or discard the adjustment layers. Click on *Flatten*. Your *Channels* palette should now contain only *Gray* instead of having the *RGB* composite and individual channels.

Duotone images are a popular method of adding tone to a monochrome image. The duotone mixes black with a pre-defined color for a richer print.

7 You now have a duotone set to its defaults, which is fine for press. If you wish to adjust the blue or black densities, click on the corresponding box for that color and adjust from there. Your *Channels* palette should now read *Duotone*.

8 Although you can print out a duotone on a standard inkjet, you might want to get it printed out by a local printshop or professional bureau. In this case, save the file in EPS format. If you do not, the duotone may not be recognized when your file is processed.

5 Go back to *Image* > *Mode* and select *Duotone*. The option box for multitoned images will pop up. Choose *Duotone* from the pull-down menu.

6 Next choose a color for your duotone. By default the first square is black. You can change this if you want to, but for this exercise we have left it as it is. Click on the empty box below the black box and a *Custom Color* picker will appear. By default the *PANTONE solid coated* chart is selected but you can change this. Even though there is no box in which to type, just type 2708. This is a light blue—the color picker will jump right to it. Click *OK*.

RECAP

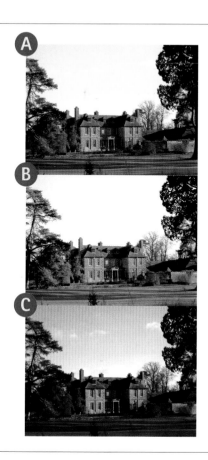

Ⓐ Create a Gradient layer
Create a *Gradient Map* adjustment layer and move the *Shadow* and *Highlight* sliders until satisfied with the image.

Ⓑ Flatten the image
Create a *Hue/Saturation* adjustment layer, make your changes and then flatten the image.

Ⓒ Choose a duotone color
Select a PANTONE color of your choice and then save the image in the EPS format.

Glossary

8-bit A color mode in a digital image, where eight data bits are allocated to each pixel, producing an image of 256 grays or colors.

24-bit A color mode in a digital image, where 24 bits of color data are allocated to each pixel, giving a possible screen display of 16.7 million colors (a row of 24 bits can be written in 16.7 million different combinations of 0s and 1s). Eight bits is allocated to each of the three RGB color channels.

anti-aliasing A technique for optically eliminating the jagged edges that appear when bitmapped images or text are reproduced on low-resolution devices such as monitors. Achieved by blending the color at the edges of the object with the background color by averaging the values of the pixels that surround it.

artifact A visible flaw in an electronically prepared image, usually occurring as a result of imaging techniques. JPEG compression, for example, reduces image data through operating on square blocks of pixels, and these can become clearly visible, particularly when high contrast or color effects are applied.

aspect ratio The ratio of the width of an image to its height, expressed as x: y. For example, the aspect ratio of an image measuring 200 x 100 pixels is 2: 1.

bit depth The number of bits assigned to each pixel in an image file. Today's computer systems can handle 24-bit or up to 16.7 million

colors. In contrast, the GIF file format can support only eight-bit color, or 256 different hues.

bitmap A bitmap is a 'map' describing the location and binary state of 'bits', so defining the location and color values of the pixels that make up a digital image.

blend mode A feature used in image-editing applications to control how the pixels in one layer interact with the pixels in the layers below. This interaction could be limited to one layer covering another, but other blend modes cause more complex changes to color or brightness values.

brightness The strength of luminescence in a pixel, going from light to dark.

burn A method used in the conventional darkroom to darken areas of an image. Often simulated in digital image-editing packages.

calibrate, calibration The process of adjusting a machine or piece of hardware to conform to a known standard. Color calibration, to maintain color consistency, is an important part of digital imaging.

capture The action of 'getting' an image, by taking a photograph with a digital camera, or by scanning an image into a computer.

CCD (Charge-Coupled Device) A component used in digital imaging hardware—including digital cameras—to turn beams of light into electrical signals that can be converted to a digital bitmap image.

clone In image-editing applications, a retouching operation where pixels from one area of an image are copied to another area using a *Brush* tool.

color cast A strong color overtone that affects all or part of an image. Usually an unwanted effect, and one that can be removed by most image-editing programs.

color picker An onscreen palette of colors in an application, from which the user can select colors to paint, draw, or otherwise manipulate an image with.

composition The arrangement of elements in a scene for aesthetic effect when captured in an image.

compression The technique of rearranging data so that it occupies less space on disk, or transfers faster across a network. Different kinds of compression technique are employed for different kinds of data—applications, for example, must not lose any data when compressed, whereas photographic images and films can tolerate a certain amount of data loss. Compression methods are described as either 'lossless' or 'lossy' accordingly.

constrain In digital imaging, to ensure that an image maintains a particular aspect ratio or proportions during resizing or resampling.

continuous tone An image that contains infinite continuous shades between the lightest and darkest tones, as distinct from a line illustration, which has only single colors. Photographic prints and slides are continuous tone images.

contrast The degree of difference between adjacent tones in an image from the lightest to the darkest. 'High contrast' describes an image with light highlights and dark shadows, but few shades in between, while 'low contrast' images have even tones and few dark areas or highlights.

crop To trim or mask an image so that it fits a given area, or so that unwanted portions of the image are discarded.

cut-out An element of an image that has been selected and separated from the rest of the picture for the purposes of composition or manipulation.

definition The overall quality—or clarity—of an image. In a photo this is determined by the combined effects of graininess and sharpness. In a digital image, resolution also has a part to play in the mix.

density The darkness of tone or color in any image. In a transparency this refers to the amount of light which can pass through it, thus determining the darkness of shadows and saturation of color.

depth of field A photographic function that defines the extent to which the area in front of the lens

will appear in sharp focus. The effects of depth of field are often used for creative purposes.

desaturate To reduce the purity of a color, thus making it grayer.

digital Anything operated by or created from information represented by binary digits. Distinct from analogue, in which information is a physical variable.

digital data Information stored or transmitted as a series of 1s and 0s ('bits'). Because values are fixed (so-called discrete values), digital data is more reliable than analogue data, as the latter is susceptible to uncontrollable physical variations.

dithering A technique of 'interpolation' which calculates the average value of adjacent pixels. This technique is most often used to add extra pixels to an image—to smooth an edge, for example, or to simulate a large range of hues from a smaller selection.

dodge A method of lightening areas in a photographic print by selective masking. Many image-editing applications can simulate the effect through digital means.

dots per inch (dpi) A unit of measurement used to represent the resolution of output devices, including printers. Also applied; erroneously, to monitors and digital images, where the resolution should more properly be expressed in pixels per inch (ppi). The closer the dots or pixels (the more there are to each inch), the better the quality of the image.

duotone A monochromatic image combining two halftones with different tonal ranges made from the same original. When printed in different tones of the same original, a wider tonal range is reproduced than would be possible with a single color. Special effects can be achieved by using the same technique and printing with different-colored inks.

exposure The amount of light allowed to reach a photosensitive material, such as photographic film or a CCD imaging sensor, to enable the recording of an image. The amount of exposure has a dramatic effect on the tonal and color values of the shot. Overexposure leads to bleached colors and poor contrast. Underexposure results in dark, gloomy, and badly defined pictures.

feathering A similar process to anti-aliasing, this blurs the edge pixels of a selection to give a soft border.

fill An image-editing operation that covers a defined area with a particular color or texture.

filter Strictly speaking, a filter can be any component in a software program that provides the basic building blocks for processing data. In image-editing and drawing applications, the term refers to advanced features used to apply special effects to an image.

gradation The smooth transition from one color or tone to another in a filled area or across an image.

gradient An effect or fill that uses gradation to control the color or brightness values of the affected pixels.

grain The density of light-sensitive crystals in a photographic emulsion. Fine grain allows more detail, but the film is less light-sensitive. Coarse grain is sometimes used for a graphic effect, and this can also be simulated using digital means.

graphic A general term describing any illustration or drawn design. Can also refer, more specifically, to 'graphic' images where the emphasis is on high-impact visuals with strong lines and dramatic tones at the expense of realism or fine detail.

grayscale The rendering of an image in a range of grays from white to black. In a digital image and on a monitor, this usually means that an image is rendered with eight bits assigned to each pixel, giving a maximum of 256 levels of gray.

halo effect An artifact created when a cut-out is copied to a new image or a different area of the same image. The pixels around the cut-out show up against the new background, creating the effect of a halo surrounding it.

highlight To mark an item, such as a section of text, icon or menu command, to indicate that it is either selected or active.

HSL A color model based on the variables of Hue, Saturation, and Lightness.

hue A color as found in its pure state in the spectrum.

image size A description of the dimensions of an image. Depending on the type of image being measured, this can be in terms of linear dimensions, resolution, or digital file size.

import To bring text, pictures, or any other form of data into a document.

interface A term most often used to describe the screen design that links the user with the computer program or website. The quality of the user interface often determines how well users will be able to access and use all the features in the program, or navigate their way around the pages within the website.

interpolation A calculation used to estimate unknown values that fall between known values. This process is used to redefine pixels in bitmap images after they have been modified in some way, such as when an image is resized or rotated, or if color corrections have been made.

JPEG (Joint Photographic Expert Group) A digital image file format used for continuous tone images such as photographs. It uses a lossy compression algorithm to squeeze large images into compact files. The Joint Photographic Expert Group created the format.

landscape format An image or page format in which the width is greater than the height. Also known as 'horizontal format'.

Glossary

layer In Photoshop Elements, a level to which you can consign an element of the design you are working on, so that you can separate it and work on it independently. Selected layers may be active (meaning you can work on them) or inactive, and can be copied, deleted, or made transparent and even invisible.

Lasso A freehand tool used in image-editing applications to select a portion of an image. In Photoshop and Photoshop Elements this also comes in a magnetic variety, which identifies the edges of a particular element, and a polygonal version, which creates straight-edged selections around an object.

levels The range of tones in an image going from the darkest to the lightest. Photoshop Elements has a *Levels* tool designed to give complete control over the tonal range of a digital photograph.

light table A table or box with a translucent glass top lit from below, giving a color-balanced light suitable for viewing transparencies and, if necessary, color-matching them to proofs.

lightness The tonal measure of a color relative to a scale running from black to white. Also called 'brightness'.

line art Diagrams and graphics comprising (normally) black lines on a white background.

lossless / lossy Refers to data-losing qualities of different compression methods: lossless means that no image information is lost; lossy means that some (or much) of the image data is lost in the compression process.

Magic Wand In image-editing applications, a tool used to select those areas of an image that possess similar brightness or color values in order to operate on them.

Marquee An image-editing tool used to make selections based on simple rectangular or elliptical shapes.

mask Originally a material used to protect all or part of a image during photographic reproduction. In image-editing applications, a mask is used to prevent alterations from affecting the masked portion of an image.

megapixel One million pixels. A term used to describe the CCD and capture capabilities of a digital camera. A four-megapixel camera takes shots of twice the resolution of a two-megapixel model.

menu bar In most applications, the bar at the top of the screen that hosts the various drop-down menus used to access and control program features.

midtones / middletones The range of tonal values in an image anywhere between the darkest and lightest—usually those approximately half-way.

moiré An unintended pattern that frequently occurs when a photograph or page from a book or magazine is scanned. Scanner software and some image-editing applications contain filters to counter it.

monochrome An image of varying tones reproduced using inks of a single color. While this is usually black ink on white paper, this isn't necessarily the case.

montage A photographic technique, simulated in Photoshop Elements, where parts from two or more images are composited to create a new picture.

multimedia A generic term used to describe any combination of sound, video, animation, graphics, and text incorporated into a software product or presentation.

opacity In image editing, the extent to which one layer is transparent or opaque, allowing the pixels in layers below to show through.

Options Bar In Photoshop Elements, the bar at the top of the screen that displays the options for the tool in current use.

palette (1) The subset of colors needed to display an image. (2) A part of the interface in many image-editing and visual-design applications, a palette is a window that contains features such as tools, measurements, options, or other functions. In most applications, palettes can be moved, hidden, and even docked together if desired.

Palette Well In Photoshop Elements, an area of the screen interface where frequently used palettes are docked. These palettes can be viewed, dragged from or dropped on to the Palette Well as needed.

panorama An image created from several shots of the same scene that simulates a large, wide-angle shot in a panoramic format.

picture skew The distortion of an image by slanting the two opposite sides of the image rectangle away from the horizontal or vertical.

pixel Acronym for picture element. The smallest component of a digital image—a single block in the bitmap grid, with its own specific color and brightness values.

plug-in Subsidiary software for a browser or other package that enables it to perform additional functions, e.g., play sound, films, or video.

polarizing filter A popular photographic filter used to remove polarized light, including reflected light, resulting in brighter colors and richer skies.

portrait format An image or page in a vertical format. Also called 'upright format'.

quick fix A tool, specific to Photoshop Elements, which allows users to correct the most common faults seen in photographs.

RAM (Random Access Memory) The memory 'space' used by the computer, into which some or all of an application's code is loaded while you work with it. Generally, the more memory, the better. Imaging software, such as Photoshop Elements, might need up to five times the amount of

available RAM that an image file would normally occupy in order to process the image.

red eye A common problem in portrait shots where the camera's flash is reflected in the blood cells at the back of the eye, giving the pupils a fiendish red cast.

rescale To amend the size of an image by proportionally reducing or increasing its height and width.

resolution The degree of quality, definition or clarity with which an image is reproduced or displayed. In a photograph this would be the result of focus, clarity, and grain structure. In a digital image, resolution refers directly to the numbers of pixels contained within a finite area of the image.

restore To return something to its original state or, in the case of a document, to its last 'saved' version. Also called 'revert'.

retouching Altering an image, artwork or film to modify or remove imperfections. Can be done using mechanical methods (knives, inks, and dyes) or digitally, using Photoshop or a similar image-editing program.

RGB (Red, Green, Blue) The primary colors of the 'additive' color model, used in video technology, computer monitors, and for graphics such as for the Web and multimedia that will not ultimately be printed by the four-color (CMYK) process.

saturation A variation in color, affecting hues of the same brightness, ranging from none (gray) through pastel shades (low saturation) to pure (fully saturated) color.

scanning An electronic process that converts a hard copy of an image into digital form. The scanned image can then be manipulated.

selection A portion of an image that has been selected for manipulation. Any adjustment will affect only this chosen area.

sepia A shade of brown, which lends its name to the sepia tone, a rich monochrome print in which shades of gray appear as shades of brown.

shadow areas The parts of an image that are darker or denser than the majority. While shadow areas can obscure detail, they create a sense of depth in a photographic image.

soft-focus An effect that softens or diffuses the lines of an image without altering the actual focus. Soft-focus has been used traditionally to confer a romantic feel to portraits, and can now be simulated in software.

thumbnail A small representation of an image used mainly for identification purposes in an image listing or, within an application, for illustrating layers or selecting an adjustment.

tonal compression The effects on an image, usually caused by scanning or printing, where the range of tones, from light to dark, is reduced to the detriment of the picture.

toolbar In applications, a standard palette which ensures that the most commonly used tools are always available at a click.

unsharp masking (USM) A traditional film-compositing technique used to 'sharpen' an image. This effect can also be achieved digitally. Most image-editing applications contain a USM filter which can enhance the details in a scanned or digital photo, and give an impression of improved clarity.

vignetting A noticeable fading at the edges of an image caused by a reduction in light levels at the edges of the frame. While this can be a problem if caused by deficiencies in a camera, vignetting can also be used to positive effect and simulated via digital means.

Index

Acknowledgments

Thanks to Bill Andrews, Jason Keith (www.jasonkeithphoto.com), Steve Luck, Rod Macdonald, and Simon Phillips for the use of their photography in the projects in this book.

Useful Addresses

Adobe (Photoshop, Illustrator)
www.adobe.com
Agfa www.agfa.com
Alien Skin (Photoshop Plug-ins)
www.alienskin.com
Apple Computer www.apple.com
British Journal of Photography
www.bjphoto.co.uk
Corel (Photo-Paint, Draw, Linux)
www.corel.com
Digital camera information
www.photo.askey.net
Epson www.epson.com
Extensis www.extensis.com
Formac www.formac.com
Fractal www.fractal.com
Fujifilm www.fujifilm.com
Hasselblad www.hasselblad.se
Hewlett-Packard www.hp.com
Iomega www.iomega.com
Kingston (memory) www.kingston.com
Kodak www.kodak.com
LaCie www.lacie.com
Lexmark www.lexmark.com
Linotype www.linotype.org
Luminos (paper and processes)
www.luminos.com
Macromedia (Director)
www.macromedia.com

Microsoft www.microsoft.com
Minolta www.minoltausa.com
Nikon www.nikon.com
Nixvue www.nixvue.com
Olympus
www.olympusamerica.com
Paintshop Pro www.jasc.com
Pantone www.pantone.com
Philips www.philips.com
Photographic information site
www.ephotozine.com
Photographic Society of America
www.psa-photo.org
Photoshop tutorial sites
www.planetphotoshop.com
www.ultimate-photoshop.com
Polaroid www.polaroid.com
Qimage Pro
www.ddisoftware.com/qimage/
Ricoh www.ricoh-europe.com
Samsung www.samsung.com
Sanyo www.sanyo.co.jp
Shutterfly (Digital Prints via the web)
www.shutterfly.com
Sony www.sony.com
Sun Microsystems www.sun.com
Symantec www.symantec.com
Umax www.umax.com
Wacom (graphics tablets)
www.wacom.com